FREE EXCHANGE

FREE EXCHANGE

Pierre Bourdieu
and
Hans Haacke

Stanford University Press
Stanford, California
1995

Stanford University Press
Stanford, California
© 1994 Éditions du Seuil/Les Presses du Réel
'Gondola! Gondola!,' the photographs and the
commentaries that accompany them, © Hans Haacke
English translation © 1995 Polity Press
Originally published in French as *Libre-Échange*
by Éditions du Seuil/Les Presses du Réel, 1994
Originating publisher of English edition:
Polity Press, Cambridge, in association with
Blackwell Publishers
First published in the U.S.A. by Stanford University Press
Published with the assistance of the French Ministry of
Culture
Printed in Great Britain
Cloth ISBN 0–8047–2495–4
Paper ISBN 0–8047–2496–2
LC 94–68698
This book is printed on acid-free paper.

Contents

Publisher's Note

This book was initiated by the Fondation de France as part of the discussions and research it organized into the nature of current cultural changes and appropriate ways of responding to them.

The Foreword, Pierre Bourdieu's part of the dialogue, and "Too Good to be True" were translated by Randal Johnson. Hans Haacke's part of the dialogue and "Gondola! Gondola!" were translated by Hans Haacke himself.

The Publishers also gratefully acknowledge the help of Joe Johnson in the preparation of this edition.

List of Hans Haacke's works reproduced in this book

Foreword

We met several times in the mid-1980s and very quickly discovered how much we had in common. The idea of this dialogue, arranged by Catherine Cullen, thus appealed to us from the outset. In November 1991, in Paris, we talked at length before a tape recorder. Then, with sometimes long delays, attributable to one or the other, we reworked the transcription, each one adding information and further reflections and reacting to the other's reactions. We hope that at the end of this lengthy process, which took a considerable amount of time, the text maintains the spontaneity of the original exchange and that, despite changes which have occurred in the political and cultural life of the United States and France, it retains its currency and efficacy.

Pierre Bourdieu and Hans Haacke
Paris and New York, 1993

PB: What strikes me about your artistic approach is that your work as a critical artist is accompanied by a critical analysis of the art world and of the very conditions of artistic production. The two forms of investigation nourish each other: your quasi-sociological observations and reflections are fully integrated into your artistic work. I have difficulty finding equivalents in the history of art, literature, and philosophy (one might think of Karl Kraus, who would put on literary *happenings* which were at the same time critiques of the intellectual world). You have a truly remarkable "eye" for seeing the particular forms of domination that are exerted on the art world and to which, paradoxically, writers and artists are not normally very sensitive. You have analyzed a certain number of examples and, in particular, you often evoke Senator Helms as a sort of incarnation of America's underlying nature.

HH: I believe that Senator Jesse Helms taught artists, and other people who care about free expression, an important lesson. He reminded us that art productions are more than merchandise and a means to fame, as we thought in the 1980s. They represent symbolic power, power that can be put to the service of domination or emancipation, and thus has ideological implications with repercussions in our everyday lives. Helms made us recognize that free expression, even though guaranteed by the Bill of Rights, is by no means secure without the vigilance of a public that is ready to fight for it. Who is this schoolmaster? The Republican Senator from North Carolina is an important figure in the network of Protestant fundamentalism and the extreme Right. He promotes right-wing movements and totalitarian regimes around the world, is a foe of trade unions, and hates women and gay people who have the audacity to claim their legitimate rights. A fierce enemy of abortion rights and of any form of sex education, he succeeded in killing a law that would have provided funds for AIDS education. His election campaigns are regularly laced with appeals to racist sentiments among white voters.

In 1989, a year before the Federal elections, this champion of decency saw an opportunity to play the fundamentalist card at the national level. The South-Eastern Center for Contemporary Art (SECCA) of Winston-Salem, in his home state of North Carolina, had put together a traveling exhibition of young artists

who had all received grants from the National Endowment for the Arts (NEA), grants that had been channelled through SECCA.[1] In Richmond, Virginia, a fundamentalist foot soldier blew the whistle: among the works in the exhibition, he had discovered a photograph by the New York artist Andres Serrano on which a crucifix could be seen through an orange veil of tiny bubbles. It was impossible to tell what this veil consisted of. The work's title explained it: *Piss Christ*. The work was part of a series of photographs by Serrano in which the (Catholic) artist worked with body fluids such as blood, semen, etc. The alarm signal from Richmond triggered a flood of letters to members of Congress, charging that public funds had been used to subsidize a sacrilege. Only a well-oiled organization like the Reverend Donald Wildmon's American Family Association of Tupelo, Mississippi, could have mounted such a campaign. This man of God had previously made himself a name with a crusade against Martin Scorsese's film *The Last Temptation of Christ*. In Congress, the first to cry "blasphemy" was the Republican Senator Alfonse D'Amato, one of the two Senators from the State of New York. For a moment he thought that this issue provided an opportunity to make political hay. But he pulled back soon afterwards, when he ran into a wave of protests in his home state.

His colleague from North Carolina, on the other hand, who did not have to take into account the cosmopolitan culture of New York, understood immediately

[1] The NEA is an agency of the Federal Government, established to support the arts. Its budget of $170.3 million (1993/94) is minuscule compared to that of comparable agencies in other industrialized countries.

that an attack on the NEA could be of use at the national level in a drive towards a conservative revolution. Shortly after the Serrano "scandal" broke, an exhibition of photographs by Robert Mapplethorpe hit the news because it had also been supported by funds from the NEA. Helms charged that the artist, who had died of AIDS, was a pornographer and had been promoting homosexuality. When fall came around, the political climate of the country had deteriorated to the point that Congress passed an amendment, introduced by Helms, which prohibited public funds from being spent on "materials which in the judgment of the National Endowment for the Arts or the National Endowment for the Humanities may be considered obscene, including but not limited to, depictions of sadomasochism, homoeroticism, the sexual exploitation of children, or individuals engaged in sex acts . . ."[2] It was the first time since the establishment of the NEA that political criteria were imposed on the professional review panels who, until then, had been the only judges deciding on grant applications submitted by institutions and individual artists.

Helms, being a consummate demagogue, made it known that those of his colleagues who would vote against his censorship law could expect to be accused in TV spots, during their campaign for reelection, of being in favor of subsidizing pornography with taxpayers' money. To dismiss accusations of this sort, politicians must spend considerable political and financial

[2]101st Congress, Public Law 101–121, October 23, 1989. In *Culture Wars*, ed. Richard Bolton (New York, 1992), p. 121.

capital — which keeps them from speaking about more important issues. Many, therefore, accepted limitations on the freedom of speech simply in order not to be caught in this bind.[3] Through his Congressional Club, a political fund-raising organization that bankrolls candidates of his choice, the Senator has another powerful instrument with which he wields political influence far exceeding that of his individual vote in the Senate.

The most recent version of the Helms amendment is fraudulently presented to the public as a compromise. Constitutional rights supposedly were preserved. However, according to the updated law of October 1990, the chairman of the NEA must insure that the agency's decisions on awarding grants are "sensitive to the general standards of decency and respect and diverse beliefs of the American public." This vague formula resembles the "gesundes Volksempfinden" that the Nazis invoked when they purged German museums of "degenerate art." In effect, John E. Frohnmayer, the chairman of the NEA, was handed what amounts to an absolute veto over the grant recommendations of

[3]Even though Democrats are in the majority in Congress and a Democrat has been in the White House since early 1993, a new Congressional attempt to abolish the NEA was rejected by fewer votes than in the previous year, during the presidency of George Bush. Apparently, it was for purely ideological reasons that Congress, this time, reduced the NEA budget, which had been kept at the same level since the early 1980s. The debate over the budget was dominated by criticism of two exhibitions at the Whitney Museum in New York, *Abject Art: Repulsion and Desire in American Art* and *The Subject of Rape.* Both exhibitions were organized by students of the Whitney Independent Study Program, a program which has a curatorial training component and has received $20,000 for its activities from the NEA. In 1994 the NEA budget was slashed by 2% to $167.4 million over the Walker Art Center's contribution of $150 to a performance by Ron Athey. The NEA then discontinued the grant program to institutions which had allowed them to fund individual artists.

his professional peer review panels. He has since exercised this veto on several occasions.[4] In order to avoid censorship, artists and institutions applying for public funds are now driven to exercise self-censorship. It is well known that self-censorship is often more effective than open censorship. And it doesn't leave a dirty trail.

PB: But there have also been cases of works banned because of obscenity.

HH: The first spectacular case was the cancellation of the retrospective exhibition of Robert Mapplethorpe by the Corcoran Gallery in Washington, in 1989, a few weeks before the opening. The exhibition had been organized by the Institute of Contemporary Art in Philadelphia, with a grant from the NEA. The museum in Washington was one of many stops on a nationwide tour which included Berkeley, Hartford, Boston, and Cincinnati. It was in Cincinnati that the director of the local Contemporary Arts Center, Dennis Barrie, and his institution were indicted for exhibiting "pornography." Cincinnati is well known for its prudishness. Because of biased statements coming from the judge and the composition of the jury, it was generally assumed that the verdict would go against the defendants. It was therefore to everyone's surprise when the jury declared them "not guilty." The prosecutor had

[4]A judge of the Federal District Court in Los Angeles ruled in June of 1992 that the law was unconstitutional. He also decided that the NEA chairman's veto of grants to four artists was motivated by political considerations and was therefore illegal. The Bush Administration appealed the decision, and the Clinton Administration continued to pursue the appeal.

been so sure of his victory that he presented only one expert witness, a woman whose credentials were her work on the childrens' TV program *Captain Kangaroo*. The defense lawyers, on the other side, presented an array of museum directors, art historians, and critics who made a convincing case for Dennis Barrie. After the verdict, members of the jury explained that they knew nothing about art, that their ideas about art were quite different from those of the experts, and that they detested Mapplethorpe's photographs. Nevertheless, they voted for acquittal. They reasoned: "All the experts say it is art. The Supreme Court exempted art from the ban of obscenity. Consequently, we have no choice but to acquit the museum and its director."

PB: When was that?

HH: It was in September of 1990. It was the first time since this campaign had been launched that a jury of the people, in whose name the advocates of morality claim to speak, clearly stated: "The Constitution draws a line that must not be crossed!" Since then, at least at the judicial level, attacks on rights guaranteed by the Bill of Rights have been less vicious.

PB: That put an end to that. But were many artists and writers mobilized in the press?

HH: Yes, among artists, in the liberal press and elsewhere. I should also mention that the Whitney Museum placed a full-page ad in the *New York Times* and the *Washington Post*, calling on readers to send letters to

Helmsboro Country, 1990

Silk-screen prints and photo on wood, cardboard, and paper. Cigarette box, 77 × 203 × 121 cm. (30½ × 80 × 47½ inches); 20 cigarettes, each 17 × 17 × 176 cm, (6½ × 6½ × 69¼ inches). Photograph of the senator by John Nordell/JB Pictures.
First exhibition at John Weber Gallery, New York, 1990. Photograph of the artwork by Fred Scruton.

Texts included in the sculpture:

— Senator Helms's warning:
"Frank Saunders, who was on the staff of the vice president for cultural affairs for the Philip Morris Co., told the Senate and the House back in 1981, and I quote him: 'Few businesses are adventurous and few are prepared to stick the company money on creative, speculative art forms. But when given the stamp of approval of the National Endowment, such art does have a chance at the board room.' That means that artists can get corporate money if they can get respectability – even if it's undeserved – from the National Endowment for the Arts. And that is what this is all about. It is an issue of soaking the taxpayer to fund the homosexual pornography of Robert Mapplethorpe, who died of AIDS while spending the last years of his life promoting homosexuality."
Source: *Congressional Record*, September 28, 1989, p. 512111.

— The warning of George Weissman, Philip Morris's executive committee chairman:
"Let's be clear about one thing. Our fundamental interest in the arts is self-interest. There are immediate and pragmatic benefits to be derived as business entities."
Source: "Philip Morris and the Arts, Remarks by George Weissman," *The First Annual Symposium, Mayor's Commission on the Arts and Business Committee for the Arts*, Denver, 5 September, 1980.

— Philip Morris funds Jesse Helms. (Philip Morris contributed to Senator Jesse Helms's electoral campaign.)
— The Bill of Rights (as distributed by Philip Morris Companies, Inc., with logos of its consumer products taken from the mailing tube with which the company sends out free copies of *The Bill of Rights*).

8

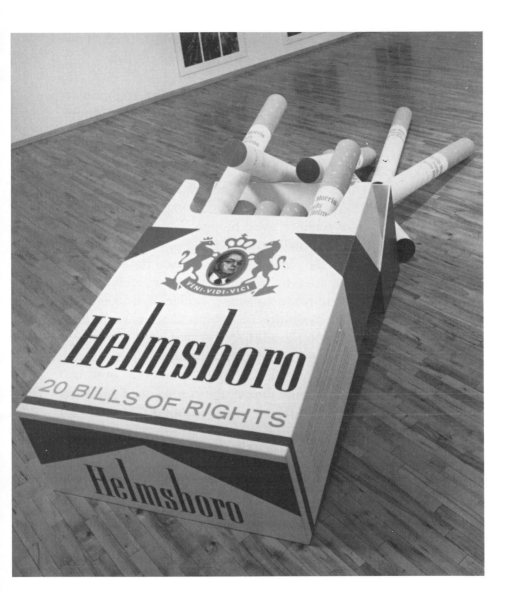

Congress. Many museum directors and trustees, however, stood back. They preferred to play it safe.

PB: Now, all of those people, who are traditionally quite discreet, practice a form of self-censorship, anticipating this kind of situation.

HH: Absolutely. In spite of the favorable verdict of Cincinnati, the majority of institutions don't dare to commit themselves to potentially controversial exhibitions. Particularly the big institutions adhere to their tradition of timidity, even though they are less vulnerable than the smaller ones. Philippe de Montebello, director of the Metropolitan Museum, is a good example: he admitted recently[5] that, well before these events, he had made a *prudent* choice of works for his retrospective exhibition of Balthus (I am not a Balthus fan; but that's irrelevant here). As far as Mapplethorpe is concerned, the great connoisseur of Fifth Avenue explained, he would have simply left out the "obscene" photos. Seen in this context, the courage and perseverance of Dennis Barrie and the support he received from his Board of Trustees, far from the presumably liberal and sophisticated East Coast, is all the more remarkable. The trial in Cincinnati cost $300,000. Although the museum got a lot of donations — the legal fees are covered — the support of the sponsors disappeared. Sponsors like to associate themselves *abstractly* with the Bill of Rights, as Philip Morris did (as part of a major public relations campaign) to the

[5]Amei Wallach, "High Stakes in Gambling Town," *New York Newsday*, April 10, 1990, p. 15.

tune of $60 million. But they are nowhere to be seen when free expression is under attack in the practical world. They don't like to have their names associated with a controversial institution. Seen from this angle, the museum in Cincinnati won a Pyrrhic victory, the kind of victory many small institutions cannot afford.

PB: Museums need cultural respectability to be able to influence their sponsors. Painters do too. There is a whole network of dependencies ... Painters need to exhibit in museums to place their works on the market or to receive public funding. Museums need to be recognized by public authorities in order to have sponsors. And all this creates a set of intersecting pressures and dependencies which, even if there is resistance, continue to exist.

HH: The pressure continues. These events have taught artists and intellectuals that, aside from individual success in terms of money and fame, there are other things that matter. There is a new sense of solidarity which had not existed for a long time.

PB: A sudden awareness of their situation.

HH: Yes, a new awareness. When the Corcoran Gallery in Washington cancelled the Mapplethorpe show, the Washington Project for the Arts (WPA) immediately took over the censored exhibition. The WPA is an institution run by Washington artists. It is supported by public funds and private donations. All exhibitions of contemporary art at the Corcoran had to be can-

11

celed. Artists didn't want to have anything to do with the museum any more. This boycott is all the more remarkable given that the majority of the artists who pulled out were not well known. An exhibition at the Corcoran would certainly have helped their careers. Disgusted by the director's censorship of Mapplethorpe, many on the staff resigned, and there was a revolt in the ranks of the members and the trustees of the museum. In the end, Christina Orr-Cahall, the director, had to resign.

PB: Do the collective structures and organizations born from that experience still exist? Are there associations that continue to function?

HH: Yes, there are artists' organizations. There are also law firms and other organizations which take a strong interest in the preservation of the freedom of expression. However, particularly among artists, these are often ad hoc campaigns.

PB: It's a case-by-case reaction.

HH: Artists aren't organizers. They hate bureaucracy and meetings. It bores them. And they lack the patience required for setting up a permanent defense system.

PB: They are very difficult to mobilize . . . That is one of the major problems encountered by every action in defense of the collective interests of writers and artists. In the first place, quite often they are not aware that they have common interests, and they limit them-

selves to defending particular interests which compete with those of the others. It takes situations like the one you mentioned, where collective interests are truly threatened, for them to understand.

If I understand you correctly, frontal attacks and direct threats to autonomy have at least one virtue: they force the interested parties to become aware of their common interests, and they encourage them to become organized to resist collectively. In France, we have not seen that kind of campaign since, perhaps, the days of the Impressionists (but it may not be long in coming).[6]

But I believe that attacks on autonomy are in a sense more dangerous when they come from a government which, like the socialist government in France, relies on the weaknesses and flaws of the literary and artistic fields — that is, on the least autonomous (and least competent) creators — to impose its solicitations and enticements. One of the antinomies of cultural policy, no matter what the area, has to do with the facts that the most autonomous productions do not have a market and cannot survive without public funding and that, at the same time, public funding, especially according to the logic of commissions and clienteles, does not necessarily go to the most autonomous and the most competent writers, artists, and scholars.

How can we deny that among the transgressions with which we identify when they are attacked by self-righteous people, there are those which do not really chal-

[6]The debate that took place [in 1993] about the avant-garde in certain semi-intellectual reviews risked opening the door to the type of public policies advocated by Senator Helms and friends.

lenge anything, either aesthetically or politically? The literary and artistic fields have always known those false revolutionaries who begin their career with brilliant ruptures, especially on the political terrain, only to wind up in the most profound conformism and academicism, and who make life doubly difficult for the true innovators. In their ultra-radical phase, they "attack" the true innovators from the Left as tepid and timorous, therefore as conformists; then in their conservative phase — that is, after their about-face — they "attack" the innovators from the Right as being implacable and beyond rehabilitation, all the while describing their own disavowals as attestations of intellectual freedom.

Sponsors who know the tune

You mention another phenomenon, that of artistic patronage. For historical reasons, private patronage has not been part of the national tradition in France, and relationships with the business world have been viewed with great suspicion. Under a certain number of very diverse influences — including the encouragement of the socialist government, which, not satisfied with working toward the rehabilitation of business and profit, also very directly encouraged researchers and artists to seek private funding — everything was reversed.

I can speak from experience. Some twenty years ago

when I wanted to undertake a study of photography, I accepted support from Kodak, not so much for the money, which was an insignificant amount, but rather for information, especially statistics, that only the company could provide. My initiative provoked extraordinary reprobation. I responded: "Wait to see my book! If what I write carries the Kodak trademark, you will have every right to criticize me." And today the very people who were indignant at the time are absolutely defenseless when it comes to patronage. They say that organisms that have not been exposed to microbes have weak immune systems . . .

Private patronage is in fashion. Some public relations firms, for example, are hired to help businesses choose the best place for their symbolic investments and to assist them in establishing contacts in the world of art or science.

In face of this, critical awareness is nil, or almost nil. People move along in a dispersed manner, without collective reflection. The same is true in relation to state-commissioned works (which we call "appels d'offre"). Lacking a collective strategy, researchers run the risk of having their objects of study, their problematics, and their methods imposed by their funding agency. We are currently in a situation quite similar to that of the painters of the quattrocento who had to struggle to win the freedom to choose, if not their subject, at least their "style." Perhaps because as artists you are more exposed to these threats — and have been for a longer period of time — and also because your own action has led you to develop defenses against the increasingly subtle strategies of business to

subordinate or seduce artists, you have a particularly lucid perspective on the threats that the new economic order represents to the autonomy of the intellectual "creators." Indeed, it may be feared that recourse to private patronage in order to finance art, literature, and science will gradually place artists and scholars in a relationship of material and mental dependence on economic powers and market constraints. In any case, private patronage may justify the abdication of public authorities, who use the pretext of the existence of private patrons to withdraw and suspend their assistance, with the extraordinary result that citizens still finance the arts and sciences through tax exemptions. Furthermore, they finance the symbolic effect brought to bear on them to the extent that the funding appears as an example of the disinterested generosity of the corporations. There is, in this, an extremely perverse mechanism which operates in such a way that we contribute to our own mystification . . .

But it would also be necessary to analyze the effects of the material and symbolic exchanges that are ever more frequently instituted between corporations and certain categories of intellectual producers, through handsomely remunerated "interventions," "consultations," "councils," or "conferences," as well as the formal or informal contacts developed in the framework of missions, commissions, associations, or foundations. Corporations have thus been successful, at least in France, in making dependent on them a good number of journalists, above all television journalists, by offering them what are called, in the language of the milieu, "ménages" — that is, well-paid participation

for leading discussions or communications training courses. And many media intellectuals have entered the *show business* of conferences for executives which permits them to earn the equivalent of a month's salary in one evening. It is not easy to measure the doubtlessly insidious effects of these kinds of practices, but it is improbable that they increase independence from economic powers and, more generally, from the values of money and profit, against which the literary and artistic worlds were, at least initially, constituted.

HH: I think it is important to distinguish between the traditional notion of patronage and the public relations maneuvers parading as patronage today. Invoking the name of Maecenas, corporations give themselves an aura of altruism. The American term *sponsoring* more accurately reflects that what we have here is really an exchange of capital: financial capital on the part of the sponsors and symbolic capital on the part of the sponsored. Most business people are quite open about this when they speak to their peers. Alain-Dominique Perrin, for example, says quite bluntly that he spends Cartier's money for purposes that have nothing to do with the love of art.

PB: Does he say in black and white, "It is to win over public opinion?"

HH: Yes. In his own words: "Patronage [*le mécénat*] is not only a great tool for communication. It does much more: it is a tool for the seduction of public

opinion."[7] It is, in fact, the taxpayers who cover what corporations save through tax deductions on their "generous contributions." In the end, we are the ones who wind up subsidizing the corporate propaganda. Seduction expenses not only serve the marketing of products like watches and jewelry, as would be the case with Cartier. It is actually more important for the sponsors to create a favorable political climate for their interests, particularly when it comes to matters like taxes, labor and health regulations, ecological constraints, export rules, etc.

PB: I once read an article which recalled that in businesses in the United States, this type of practice is justified by what is called the *check account theory*, the theory of the (symbolic) bank account. A foundation that makes donations accumulates symbolic capital of recognition; then, the positive image that it is thus assured (and which is often assessed in dollar terms, under the heading of *good will*, on business account sheets) will bring indirect profits and permit it, for example, to conceal certain kinds of actions.

HH: To quote Monsieur Perrin: the strategic goal is to "neutralize critics."

PB: In the world of high fashion, it is well known that the annual presentation of the new collections assures designers the free equivalent of hundreds of

[7]Alain-Dominique Perrin, "Le Mécénat français: La fin d'un préjugé," interview with Sandra d'Aboville, *Galeries Magazine*, no. 15 (Paris, October–November 1986), p. 74.

pages of advertising. The same goes for literary awards. In all cases, it is a question of controlling the press and getting it to write favorably about the companies at no cost. Firms that invest in patronage make use of the press and oblige it to mention and praise them. In a very general sense, economic leverage is exerted on cultural production largely through the medium of the press, particularly through the seduction it exerts over producers — especially the most heteronomous — and through its contribution to the commercial success of works. It is also exerted through dealers in cultural goods (editors, gallery directors, among others). It is above all through journalism that commercial logic, against which all autonomous universes (artistic, literary, scientific) are constructed, imposes itself on those universes. This is fundamentally harmful, since it favors the products and producers who are most directly submissive to commercial demands, such as the "journalist philosophers" of whom Wittgenstein speaks.

Creating a sensation

But, in fact, through your work you carry out a diversion of the processes used by wise managers. You use an analysis of the symbolic strategies of "patrons" in order to devise a kind of action that will turn their own weapons against them.

I find this exemplary, because for years I have asked myself what can be done to oppose modern forms of

symbolic domination. Intellectuals — but also unions and political parties — are truly unarmed; they are three or four symbolic wars behind. They have only archaic techniques of action and protest to use against corporations and their very sophisticated forms of public relations. Thanks to your artistic competence, you produce very powerful symbolic weapons which are capable of forcing journalists to speak, and to speak against the symbolic action exerted by corporations, particularly through their patronage or sponsorship. You make symbolic machines that function like snares and make the public act. For example, as in the case of Graz, you compose a work, the work's enemies destroy it, thus unleashing a whole chain of discourses that force a deployment of critical intent. These works make people talk, and, unlike those of certain conceptual artists, for example, they do not make people talk only about the artist. They also make people talk about what the artist is talking about. Through facts and actions, you prove that it is possible to invent unprecedented forms of symbolic action which will free us from our eternal petitions and will put the resources of the literary and symbolic imagination at the service of symbolic struggles against symbolic violence. I am thinking, in this connection, of a poem by Pinter against the Gulf War (censored by the British press and published later in *Liber*), which was also a response to the acknowledgment of the impotence of intellectuals in face of journalists' stranglehold on all forms of mass media. Not only are artists, writers, and scholars excluded from public debate and public expression (those who opposed the Gulf War, for example, had to

face formidable obstacles, to say nothing of the efforts of young Yugoslav intellectuals to stop the barbarity of the civil war!), but it is fashionable to say that they no longer exist! A certain number of media intellectuals collaborate with those in the media who conspire more or less consciously to discredit intellectuals, or, to speak in a more rigorous manner, who contribute to reinforcing all the mechanisms (among which are the effects of urgency) which tend, apart from all malicious intentions, to make the dissemination of complex messages difficult.

It is not a question of making journalists as a whole responsible for destroying the critical power of intellectuals. If it is through them that constraints and controls are instituted, it is also through them, or certain among them, that some areas of freedom may open. That being said, your work is so important, in my opinion, because, in part, it indicates the direction artists and scholars should look in order to give their critical actions a true symbolic efficacy.

HH: Occasionally, I believe, I have succeeded in producing works which have played a catalytic role. But I think works that do not get much public attention also leave a trace. All productions of the consciousness industry, no matter whether intended or not, influence the social climate and thereby the political climate as well.

In the specific cases we are discussing, the problem is not only to say something, to take a position, but also to create a productive provocation. The sensitivity of the context into which one inserts something, or the

manner in which one does it, can trigger a public debate. However, it does not work well if the press fails to play its role of amplifier and forum for debate. There has to be a sort of collaboration. The press often plays a double game without being quite aware of it or, at least not openly, showing that it does.

This ambiguous position is due in part to the enormous pressure to fill pages and the screen with ever new stimuli, extraordinary events, and stuff that's different from what we have been seeing and hearing daily and that can therefore capture our attention. Lest we forget, journalism is not a monolithic enterprise: there are people who are quite willing to help us. I told you about my experience in Munich. Ruhrgas AG, one of the German companies I had named on my flags on the Königsplatz for having sold war material to Iraq, became quite irritated. When the company obtained a temporary injunction, I called the journalist of *Der Spiegel* whose article had been the source of my information. Hearing what had happened in Munich, he told me: "This is remarkable. There was no response whatsoever from Ruhrgas to my article. But you got it. Apparently, when it happens in a public place, they react. That embarrasses, that creates a sensation." The Munich newspapers which already had published illustrated reviews now followed them up with reports on the moves of Ruhrgas in the legal arena.[8] The upshot of their complaint was that a statement had to be inserted in the catalogue explaining that, strictly speak-

[8]To celebrate the twentieth anniversary of its relations with Russia, in 1993, Ruhrgas sponsored an exhibition of the Shtshukin and Morosow collections, at the Folkwang Museum in Essen.

ing, it was a wholly owned subsidiary[9] of Ruhrgas that was the supplier of Iraq, and not Ruhrgas itself. Thus the name of Ruhrgas was highlighted in the list of 21 companies on my flags.[10]

PB: There is a kind of censorship through silence. If, when one wants to transmit a message, there is no response in journalistic circles — if it doesn't interest journalists — then the message is not transmitted. Journalists have been the screen or filter between all intellectual action and the public. In a book entitled *Produire l'opinion*,[11] Patrick Champagne shows, *grosso modo*, that successful protests are not necessarily those that mobilize the most people, but those that interest the most journalists. Exaggerating somewhat, we could say that fifty shrewd people, capable of staging a successful *happening* that gets 5 minutes of television airtime, can have as great a political effect as 500,000 protesters.

This is where the specific competence of the artist is so important, because a person cannot just suddenly become a creator of surprise and disconcertion. The artist is the one who is capable of *making a sensation*, which does not mean being sensational, like television acrobats, but rather, in the strong sense of the term, putting across on the level of sensation — that is, touching the sensibility, moving people — analyses which

[9]*Wer gehört Wem?*, Commerzbank, 1990.

[10]The prohibition against exhibiting the flags with the Ruhrgas name had no practical effect, because, by the time of the ruling, the exhibition had ended.

[11]*Produire l'opinion. Le nouveau jeu politique* (Éditions de Minuit, Paris, 1990).

Raise the Flag, 1991

Temporary public installation.
Two flags measuring 1100 × 250 cm (437 × 98 inches); another with silk-screen print, 550 × 350 cm (217 × 138 inches).
Group exhibition entitled *ArgusAuge* (Argus's eyes), September 1991, Königsplatz, Munich.
Exhibition curator: Werner Fenz for the Städtische Galerie im Lenbachhaus, Munich.
Technical direction: Daniela Goldmann.
Photos: Philipp Schönborn.

The title of the work is the first line of a famous Nazi song, the *Horst-Wessel-Lied*.

other, contain museums, one for minor Greek and Roman art, the other (Glyptothek) for the royal collection of Roman replicas of Greek statuary. A road crosses the grass-covered square leading to the third structure, a massive triumphal gate known as the Propylaeum. This gate commemorated the king's son, Otto I, and the victory of the Greeks over the Turks during the Greek wars of liberation. Christian and Bavarian symbols abound in reliefs representing battle scenes on the fortress-like towers of the martial edifice. The pediment is

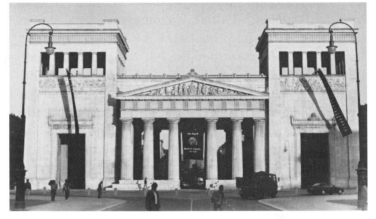

On the central flag one can read: "Roll call — German Industry in Iraq." The image of the death's head is a photo of an SS badge. The other flags show a list of German companies.

Eight artists, none of whom reside in Germany, were invited to produce works incorporating photography referring to the history of the site where they were to be exhibited.

Königsplatz, a well-known square in the heart of Munich, was developed under King Ludwig I of Bavaria in the first half of the nineteenth century.

The architect Leo von Klenze designed an ensemble of three neoclassical buildings around the square. Two of them, facing each

dominated by the statue of the seated Otto I, who had been placed on the Greek throne by a coalition of Russia, England, and France. Standing to the right is a man resembling Christ. To the left are two figures looking at each other. One of them is almost naked, but wears a helmet; the other, clad in a short tunic, leans on a ship's rudder — representations of the warrior and merchant classes.

Ludwig I left the throne in 1848 under pressure from subjects who were no longer content to be governed by divine right and without a constitution. For the same reasons, also his son's power over Greece was the target of growing unpopularity. It was only after his

abdication, on the day of his return to Munich, that the Propylaeum was inaugurated.

After Hitler's takeover in 1933, Königsplatz became the principal site for Nazi rallies in Munich. The ground was covered over with granite slabs, and Paul Ludwig Troost, Hitler's architect, designed a closure for the fourth (still open) side of the square. Two massive buildings, one serving as Hitler's Munich office, the other as the headquarters of the Nazi party, thus came to guard the entrance to the square and provide the backdrop for two *Ehrentempel* (temples of honor). They were erected by the Nazis as sanctuaries where they buried the dead from their failed, 1923 putsch in Munich. During the Nazi regime, every year,

Like the firms of other countries, German companies made major contributions to the Iraqi arsenal, including Saddam Hussein's nuclear and chemical weapons manufacturing program. Siemens has been cited as a supplier of nuclear technology.[1] MBB, part of the aerospace division of Daimler-Benz, in conjunction with French partners, sold helicopters and missiles to Iraq.[2] Siemens and MBB have their headquarters in Munich. Both companies, like many other suppliers of Saddam Hussein's war machine, once provided Hitler with war material. Dachau is a short ride from Munich.

After the Gulf War, Daimler-Benz ran an advertisement in Germany[3]: "We are fascinated by technological progress, and we are

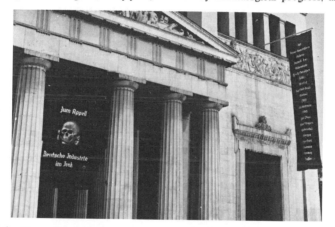

on the day of the November putsch, a commemorative ceremony took place on the Königsplatz. In front of thousands of troops at attention, the names of the dead were called as they might have been for a roll call. At the intonation of each name, someone in the crowd would answer "Here!"

After the war, these "temples" were dynamited by the American army. The buildings which sheltered the Nazi offices now welcome the Music School and the Institute of Art History of the University of Munich.

committed to continually improving and perfecting performance. But we forget, sometimes, that there are other things, as well, which are equally important: art, for example. If we integrate art into our everyday life, it prompts us yet again to see the world anew."

[1]"Atom-Hilfe für Saddam Hussein?" *Der Spiegel*, 52 (1990), pp. 69–71.

[2]"Treffer mit Roland," *Der Spiegel*, 39 (1990), pp. 32, 33.

[3]*Frankfurter Allgemeine Zeitung*, 1990.

AEG

Bauer-Kompressoren

Buderus

Daimler-Benz

Gildemeister

H + H Metallform

Havert

Hochtief

Karl Kolb GmbH

Klöckner

MAN

Mannesmann

MBB

Pilot Plant

Rhein-Bayern

Rheinmetall

Ruhrgas

Saarstahl

Siemens

Strabag

Thyssen

would leave the reader or spectator indifferent if expressed in the cold rigor of concept and demonstration.

You should be a sort of technical advisor to all subversive movements . . .

Real simulacra

HH: In his report on "patronage" [*mécénat*] for the Minister of Culture (at the time it was François Léotard), Monsieur Perrin, that expert *extraordinaire* of communication, stated clearly: "The effectiveness of this strategy of communication is not limited to creating the event, it is also necessary to make it known: the media have to be a partner. Patronage is media-oriented . . . It is part of the media and it uses the other media as support." The press is the immediate target audience. The seduction of public opinion cannot succeed without the collaboration of the press. Public opinion is a battlefield (please excuse my use of this martial image) we must not desert. We should learn from the enemy.

PB: I won't reproach you for using that language. The intellectual world is a site of often fierce struggles, and the independence and autonomy of intellectuals are ceaselessly threatened by all sorts of external forces, the most formidable of which today is no doubt journalism, a power which is itself dominated by other powers,

such as those of politics, which are more or less insidious, or those of the economy, notably through the weight of advertising, thus of advertisers, in the press's finances. This is because, contrary to what many scholars and artists think, we do not face the alternative of submission to the press or retreat into the ivory tower, which is a form of desertion. (Quite often, those who violently condemn all contact with journalism are the first to submit to its solicitations when, by chance, they become its subject ...). According to the model invented by Zola, we can and must intervene in the world of politics, but with our own means and ends. Paradoxically, it is in the name of everything that assures the autonomy of their universe that artists, writers, or scholars can intervene in today's struggles. And we are all the more enjoined to intervene in the world of men of power, business, and money, the more they intervene — and the more effectively they intervene — in our world, notably by injecting their cheap "philosophy" into the public debate. Since television hardly ever presents "intellectuals" who are better than they, nothing keeps them from thinking that they are the thinkers. Thus far M. Perrin has been content to produce theories for internal use on the best strategies for selling his diamonds. One of these days, he will discover that he is a philosopher. We will see him on television telling us what he thinks about the world, war, peace, the republic, the Right, the Left, and he will be a celebrity ...

As an artist, you are relatively well-protected. One can't imagine a chief executive officer putting on an exhibition in New York. But those of us in philosophy

and the social sciences are going to be overrun. There are already business and government thinkers. If on top of it all he has graduated from the École Nationale d'Administration or the Polytechnic, a more or less competent businessman or well-known bank director can, with the support of certain journalists, pass himself off as an intellectual leader, write his best-seller every year, present "his" ideas on television, and comment every other minute on all subjects, even the most scientific, in newspapers and news weeklies.

All these people are a step beyond the examples we are using. They not only promote their products; they also promote the producers, which is to say, themselves. In order to promote themselves, they bring into play the techniques used to promote their products (and also, quite often, to produce them, such as conscious or unconscious plagiarism or recourse to the sorts of subcontractors of the cultural industry that in the past were called "nègres," or ghostwriters). And it is all the easier because there are more and more "intellectuals" who do the same thing — that is, intellectuals without a substantial record of work who manage to exist by writing in newspapers and by publishing books that are simple collections of articles or which are produced with an eye toward receiving the approval of newspapers.

Even now, journalists successfully challenge philosophers and scholars in their effort to tell the truth about the world, and particularly about the social world. They are no longer content just to *report* information; they want to produce it. And in fact, they are in a position to "create the news," to impose the sub-

jects of discussion and reflection from day to day, as well as the obligatory reflections on the imposed subjects. Never have moralism and conformism been imposed so continuously and with such violence through television, and it is significant that literary prizes more and more frequently consecrate journalists, who are thus confirmed in their role as poor men's intellectual guides. These same journalists occupy the top spots in the best-seller list (which is, today, what the Neilsen rating is to television) with their biographies of politicians, their firsthand accounts as manservants of great men, or their pathetic pamphlets on the affairs of art or culture.

HH: It is perhaps worth mentioning that the ambassador of Rembrandt on the Place Vendôme apparently understood that my work *Les must de Rembrandt* could interfere with his strategy of seduction. The people in charge at the Centre Pompidou were fortunately courageous and independent enough not to give in to pressures. In the private museums of the United States, the land of "free enterprise," a telephone call would probably have had the desired effect.

PB: In any case, very rare are those who are aware of the threats to their autonomy, whether those threats come from publishers or from journalism, from academies or prize juries, from ministers of culture or committees, from works commissioned by the state or private patrons. Even rarer are those who are prepared to give up narcissistic gratifications or the sym-

Les must de Rembrandt, 1986

Installation at Le Consortium, Dijon. Reconstructed at the Centre Georges Pompidou in Paris for the exhibition *L'Epoque, la mode, la morale, la passion* in 1987 and for a personal exhibition in 1989 at the same location.
Photograph included in the artwork by William Campbell/Sygma. Photographs of installation by André Morin and Hans Haacke.

The Compagnie Financière Richemont in Switzerland[1] and the Richemont S.A. in Luxembourg are interconnected, holding companies for the external assets of the Rembrandt Group of South Africa, the largest Afrikaner business empire of that nation. The

luxury goods sector. It holds 77.3 percent of Cartier Monde (including Les must de Cartier), as well as 57 percent of Alfred Dunhill with its subsidiaries Chloë and the German pen manufacturer Montblanc. Through Cartier, it controls the Swiss watchmakers Piaget and Baume & Mercier. In addition to Chloë, other fashion houses, such as Valentino, Karl Lagerfeld, and Yves Saint-Laurent (6 percent) have entered the orbit of Financière Richemont.[3]

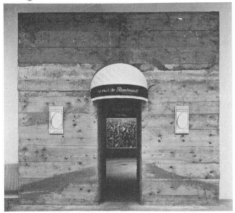

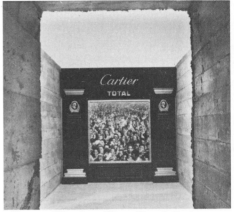

shares of Financière Richemont are traded on stock exchanges in Geneva, Basel, Zurich, and Johannesburg. Since Richemont is not a South African entity, even though it was controlled by Rembrandt during the years of apartheid, it protected its parent from sanctions against South Africa and it represents its interests in the European Common Market. Financière Richemont owns 62.8 percent (all shareholding figures are from 1992) of the shares of Rothmans International, the fourth largest tobacco company in the world. In 1992, it joined a consortium of investors who together own 75 percent of Filmnet, the principal cable channel in the Scandinavian and Benelux countries. It is suspected by Italian prosecutors of having acquired an interest in Silvio Berlusconi's Fininvest media empire, too.[2]
Financière Richemont also plays a major role in the

[1]Sources: *Who Owns Whom* (Dun & Bradstreet, 1992). *Moodys*, 1992. *FT Analysis*, Financial Times Information Service, 1993. *Smith New Court Securities, PLC*, Information Service, 1992–3. "The Quiet Afrikaner behind Cartier," *Forbes*, New York, April 2, 1990, pp. 114, 145. "Test of Commitment," supplement to *Financial Mail*, Johannesburg, June 22, 1990, pp. 63–9. "Richemont Currency Savings," *Financial Mail*, Johannesburg, August 23, 1991, pp. 81, 82.
[2]"Gefährliche Liebschaften," *Der Spiegel*, Oct. 1994, pp. 120, 121.
[3]From a report in *FT Financial Analysis*, 30 June 1993.

32

The Rembrandt Group was founded in 1940 by Anton Rupert. He enjoyed the support of Afrikaner capital, in an alliance with the backbone of the old apartheid politics, the Nationalist party, and the Afrikaner Broederbond. The group is still dominated by the Rupert family.

In South Africa, Rembrandt has major interests in mining, engineering, investment banking, insurance, financial services, petrochemical products, forestry and timber processing, printing and packaging, tobacco, food, and alcohol. Besides a 17.3 percent share in Gold Fields of South Africa, Rembrandt has a 25 percent stake in GENCOR, the second largest South African mining company.

work of some 700 service stations, and is one of the suppliers of the South African army and police.

Like the Rembrandt Group in South Africa, Cartier has sponsored the visual arts in France. In 1984 Alain-Dominique Perrin, the head of Cartier, established the Fondation Cartier pour l'art contemporain in Jouy-en-Josas in the Parisian suburbs. The foundation has since mounted a number of exhibitions, certain of which were directly related to the world of luxury products. In 1994 it moved into a new building, together with the Cartier company headquarters, in the centre of Paris.

A 1634 self-portrait by Rembrandt serves as the logo of the Rembrandt Group.

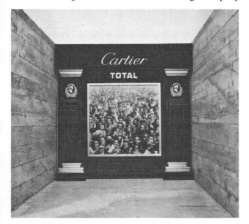

GENCOR also operates in other industrial sectors, including the production of armored vehicles and warships. Because of the brutal treatment of its black work force and its violent suppression of strikes, GENCOR was declared an "enemy company" by Cyril Ramaphosa, the then president of the National Union of Mineworkers and presently the secretary general of Nelson Mandela's African National Congress (ANC). In 1986 negligence regarding safety measures in one of the GENCOR mines caused the deaths of 177 black mineworkers.[4] GENCOR is a mining partner of Total South Africa. With a 57.6 percent stake in the latter, the Compagnie Française des Pétroles is the largest French business enterprise in South Africa. Rembrandt controls the remaining shares. Total satisfies a substantial part of South African petroleum needs. It operates a net-

[4]"Toll at Mine is 177, South Africans Say; Lax Safety Charged," *New York Times*, September 18, 1986. "Lesson from Kinross," *Financial Mail*, Johannesburg, September 26, 1986, pp. 34, 35.

In September 1985, the black workers at GENCOR's gold and coal mines go on strike. The company breaks the strike with teargas bombs, firearms, and dogs. It also evicts the strikers from their quarters and fires a great number of them.

In January 1986, the black workers at GENCOR's platinum mines go on strike. 23,000 strikers are fired. Johan Fritz, the director, states: "We have a shield against their irresponsible actions — a great reserve of unemployed."

REMBRANDT GROUP
Afrique du Sud

Cartier Monde
Bijouterie Accessoires
Joaillerie Expositions d'art

Total South Africa
Pétrole Uranium
Charbon Energie solaire

Gencor
Or Minéraux
Platine Bois
Uranium Papier
Charbon Transport maritime
Métaux Ingénierie

Trans-Hex
Diamants

Metcor
Acier Ingénierie

Rothmans
Produits de tabac Pétrole
Bière Gaz
Vin Appareils ménagers
Spiritueux Expositions d'art
Articles de luxe

Cape Wine & Distillers
Vin Spiritueux

W & A Gilbey
Vin Spiritueux

Henkel South Africa
Détergents Adhésifs

Stewarts & Lloyds
Compagnie maritime

Volkskas
Banque

Boland Bank
Banque

Legal & General Volkskas Insurance
Compagnie d'assurance

Momentum Life Assurers
Compagnie d'assurance

Sage Holdings
Compagnie d'investissement

Rembrandt van Rijn Art Foundation
Exposition d'art

Partnership in Industrie
Holding (Luxembourg)

Partnership in Industrie
Holding (Suisse)

Rupert Foundation
Holding (Luxembourg)

En septembre 1985, les travailleurs noir[s] [des] mines d'or et de charbon de GENCO[R] mettent en grève. La société brise la gr[ève à] l'aide de bombes lacrimogènes, d'armes à f[eu,] de chiens. Elle expulse aussi les gréviste[s de leurs] foyers et en licencie un grand nombre.

vier 1986, les ouvriers noirs des mines de

e de GENCOR se mettent en grève. 23 000

tes sont licenciés. Johan Fritz, directeur,

e: "Nous avons un bouclier contre leurs

s irresponsables–une grande réserve de

eurs."

bolic profits which are offered (especially since refusals, which appear only through their absence, are doomed to go unnoticed ...).

HH: Corporate strategies have become more and more sophisticated. As an example, I am thinking of the scientific conferences organized and financed by the Reverend Moon. The prestige gained through these seemingly innocuous events allows him to pursue his political agenda without major problems. Cartier consultants are also more astute today than they used to be. They master the art world's jargon and have the money to construct a cultural façade. For the catalogue of their exhibition *Nos années 80* [Our Eighties] they managed to get a text from Paul Virilio on *The Decade of Paradoxes*. In 1988, the Cartier Foundation staged a big exhibition with the title *Vraiment Faux* [Truly False/ Fake]. The reference point was the Mona Lisa, while the buzz words of the day, "simulacrum" and "simulationism," gave it a stylish air.

The subtext of this project of *animation* (a very French and untranslatable term) was the struggle of Cartier, and other big-name brands, with fakes of their luxury products. It was quite amusing to watch how the notion of the simulacrum had been co-opted and inverted in order to defend authenticity.

PB: That's Baudrillard!

HH: Yes, that's Baudrillard. A fascinating phenomenon. Like McLuhan, his adopted father, Baudrillard has gathered around his feet a congregation of the

faithful from the world of advertising, the media, and the arts. Since the end of the 1980s he has lost some of his followers in the art world, the world I know best.[12] This decline has accelerated, due to the collapse of the art market and the devastation of AIDS. People in New York were not amused by his comparison of AIDS with a "viral catharsis" which, in his terms, is "a remedy against total sexual liberation which is often more dangerous than an epidemic." (This is what he said in an interview in a German art magazine.)[13] Baudrillard had once found devotees among the downtrodden of the intellectual Left who were desperately searching for an exit from Marxist orthodoxy. Perhaps it was his writings on the consumer society and the political economy of the sign from the early 1970s that gained him a following in this disillusioned crowd. What he and his disciples have lost since is a sense of history and social conflict, which, in spite of the fireworks of the latest intellectual fashions, do not dissolve in the virtual. In short, they have lost a sense for the real. The ecstasy of communication, a quasi-mystical state, is expected to deliver them from the shitty reality of the everyday. This miracle is to occur in the style of the Baron of Münchhausen, through the very communication practiced by the faithful. There is no reality, no reason to fight . . .

[12]Nevertheless, *Galeries Magazine* (no. 53, March-April 1993) offered a portfolio of seven Baudrillard photographs for 3500 French francs. These photographs were exhibited in one of the satellite exhibitions of the Venice Biennale in 1993.

[13]Conversation of Florian Rötzer with Jean Baudrillard, "Virtuelle Katastrophen," *Kunstforum International*, Cologne, January-February 1990, p. 266.

Baudrichard's Ecstasy, 1988

Gilded urinal, ironing board, fireman's bucket, recycling pump, rubber hoses, water.
Photograph by Fred Scruton.
First exhibited at John Weber Gallery, New York, 1988.

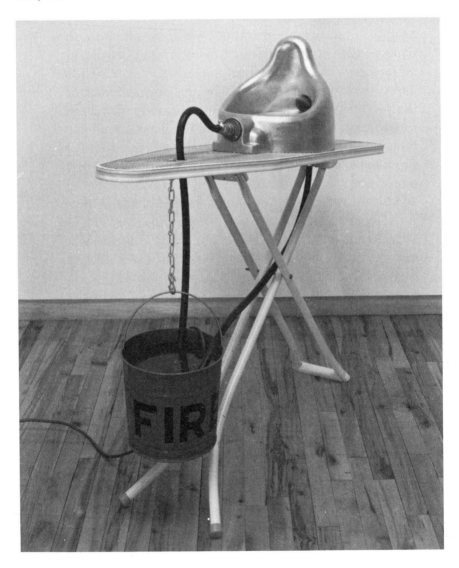

PB: . . . in order to change it?

HH: . . . in order to change it. It would be ridiculous to fight a simulacrum. Everything has equal value in this hall of mirrors. We should rather let ourselves be seduced. But in the practical world, the evacuation of the political is tantamount to inviting whoever wants to occupy the vacuum that's left behind, including political gangs like the National Front.[14] You probably remember how, in January of 1991, the prophet of the simulacrum announced in *Libération*: "There will be no Gulf War."[15] A few months later, the great dis-simulator offered us a collection of his analyses under the title *The Gulf War Did Not Take Place*.[16] Such an escape from reality looks to me more and more like a mental disorder. But there is also an occasional sign which demonstrates that Baudrillard has, in fact, not left the world of real exchanges. When *Der Spiegel* asked him whether he would accept an invitation to visit the battlefield in Iraq, he answered: "I make my living with the virtual."[17]

That makes me think of the preface which the chairman of Daimler-Benz, Edzard-Reuter, wrote for the catalogue of the exhibition of *Cars* by Andy Warhol at the Guggenheim Museum. He asked himself: "Does

[14]French extreme right-wing political party, led by Jean-Marie Le Pen and known for its racist policies.

[15]*Libération* (Parisian daily with national distribution), January 4, 1991, p. 5.

[16]Jean Baudrillard, *La Guerre du Golfe n'a pas eu lieu* (Éditions Galilée, Paris, 1991).

[17]*Der Spiegel* (German news weekly), "Der Feind ist verschwunden," no. 6 (February 4, 1991), pp. 220, 221.

this mean that patronage of the arts is a form of advertising by alternate means?" As one could expect, he emphatically rejected the notion that his company's commission for Andy Warhol's portraits of Mercedes automobiles and sponsorship of their exhibition, has anything to do with marketing. His explication was remarkable. He substituted the economic value the sedans have for Mercedes shareholders with purely symbolic values. He thus managed to blend market value with art. Roberta Smith, a critic of the *New York Times*, who is conversant with the discourse of the art scene, wondered in her review whether Herr Reuter was a disciple of Baudrillard.[18]

There was another exhibit at the Cartier Foundation which caught my interest: *Les années 60* [The Sixties]. I saw it in Jouy-en-Josas in 1986.[19] It was a Hollywood production, complete with cover story in *Paris Match* done in corresponding style.[20] The most fantastic image in this copy of *Paris Match* was a double-spread photo of rioters, accompanied by models in *haute couture* garb, as they were posing on the cobblestone barricades the ground-keepers had erected in the Foundation's parking lot. In the center of this scene, engulfed by the smoke from smoke machines, a fearless demonstrator brandished a placard with the slogan "It is forbidden

[18]Roberta Smith, "Andy Warhol, 'Cars': Last Works of the Artist," September 30, 1988, p. III 24.
[19]The Cartier Foundation moved in 1994 from the Parisian suburbs to Boulevard Raspail, in the center of Paris.
[20]Dominique Ottavioli and Jean-Claude Zana, photos Georges Melet, "1960–69: La nostalgie des Sixties," *Paris Match*. Published as a catalogue by Fondation Cartier, 1986.

to forbid." This image was a precursor to the *Truly False* [Fake], a real simulacrum.

PB: This refinement of symbolic strategies is no doubt also explained sociologically. Today, an increasingly large fraction of owners and upper management throughout the world graduates from the best schools. Although they may not be great intellectuals, those who dominate the economic world, the owners of industry and commerce, are no longer the narrow-minded bourgeois of the nineteenth century. In the nineteenth century, artists such as Baudelaire and Flaubert could oppose the "bourgeois" as ignorant or dim-witted philistines. Today's owners are, often, very refined people, at least in terms of social strategies of manipulation, but also in the realm of art, which easily becomes part of the bourgeois style of life, even if it is the product of heretical ruptures and veritable symbolic revolutions.

HH: The message was that the Sixties were, above all, a decade of revolutionary developments in fashion, pop music, and sports cars. Lined up on the lawn of the Foundation were a dozen luxury cars that had once belonged to movie stars and sports figures of the 1960s. The photo of a speedometer capable of revving up to 240 kilometers per hour served as logo for the show. In the main hall of the bunker where, during World War II, German officers had been leaning over battle maps, the big fashion houses of Paris had been invited by their colleagues at Cartier to display their wares.

PB: Is it the bunker in Jouy-en-Josas that you evoke in your work on Cartier?

HH: Yes. It made reference to the concrete fortification in the park of the Foundation. It also alluded to Egyptian tombs and to prison yards. Video monitors in the bunker were presenting a ten-minute loop of the most important news stories of the decade. The tape was in black and white – with the exception of one key event of 1968: Robert Hocq's creation of a golden cigarette-lighter for Cartier. This event was commemorated in color. The lighter was the first of the "must."

PB: And what about events such as the student movements?

HH: Very little, and treated like a bit of miscellaneous news among other trivia.

PB: That makes me think of one of the typical books of the new *vulgate* which seek to destroy critical intellectuals, *La Pensée 68*.[21] Like the Cartier Foundation's exhibition on the 1960s, *La Pensée 68* attempts to prove that all of that is outmoded and finished; that the 1960s, May 1968, Sartre, Foucault, Derrida, and a few others, never existed; that it is necessary to go back to Kant, to democracy, to the rights of man and to the Pope (a recent novel by one of our fashionable writers, a former Maoist in the 1970s and a prophet of all transgressions,

[21]Luc Ferry, Alain Renaut, *La Pensée 68. Essai sur l'antihumanisme contemporain* (Gallimard, Paris, 1985).

42

especially sexual transgressions, celebrates action in favour of morality and virtue).

HH: The subliminal message of this show of the 1960s was that the conflict between the Soviet Union and the United States in Berlin, Cuba, in Vietnam and elsewhere around the world, the war in Algeria, and the May events of 1968 in France — all these events had lost their significance. What counts in the end, what remains, is the lighter of Monsieur Hocq, high fashion, and the world of luxury inhabited by the Cartier clients. The only threat to the survival of this world comes from fake Cartier watches. That's where the South African company shows its concern for reality.

PB: Not everything is a simulacrum . . . Hong Kong exists! But the analysis of patronage and the constraints or increasingly subtle censorship that corporations impose on cultural production has diverted us from the analysis of the specifically political pressures which, especially in the United States, are brought to bear on the intellectual world. We need to come back to the paleo- and neo-conservatives (*neocons*) and to the increasingly organized action that they lead, both nationally and internationally, through the press, foundations, professional organizations, and so forth.

HH: OK. There is Patrick Buchanan, a journalist who made himself a name as ghostwriter for Nixon and, more recently, as White House director of communications for Ronald Reagan. He honed his debating talents for many years on the *McLaughlin Group*, a conservative TV show. He is a representative of the old Right. He is close to the conservative wing of the Catholic Church, anti-intellectual, xenophobic, and isolationist. He loves racist innuendo. In his newspaper column, he proposed to start the cultural revolution he envisions at the National Endowment for the Arts.

PB: He wrote in the *Washington Times*, didn't he?

HH: Yes. He was [until his election campaign in 1991][22] a columnist for the *Washington Times*, the daily newspaper of the Unification Church of the Reverend Sun Myung Moon. The paper had very good relations with the White House [under Reagan and Bush]. Buchanan's articles were syndicated and appeared regularly

[22]Buchanan ran against George Bush in the Republican primaries for the presidency. In TV spots Buchanan accused Bush of having subsidized homosexual pornography (which "pervert[s] the image of Christ") with NEA support for the film *Tongues Untied* by Marlon T. Riggs. Even though the grant for the film on the life of black gay men amounted to no more than $5,000 and had been awarded by the Administration of his predecessor, Bush repudiated his NEA chairman John E. Frohnmayer and fired him in order to pacify the right-wing Republicans whose votes he thought he needed. He went so far as to invite Buchanan to speak at the Republican Convention. Buchanan's speech was so aggressive and extreme that even moderate Republicans were deeply shocked.

in many other American newspapers as well. This Savonarola of the Right appealed to conservative Middle America, the natural constituency of Republicans and people like Jesse Helms.

Aside from this stripe of traditional conservatives (the paleo-conservatives), most of whom are anti-Semitic, racist, and authoritarian, there is another camp: the neo-conservatives who are at least as influential. The two groups hate each other. However, in spite of their internal conflicts, they have succeeded, since Reagan's arrival in the White House, in framing the political debate of the nation. Liberal [liberal in the American sense of the word] ideas are being called into question not only by the Government but also in the media. Most of the leading neo-conservatives are intellectuals from New York. It is interesting to note that Irving Kristol, the godfather of American neo-conservativism, and many of his buddies (from different generations), had once been Trotskyites or had belonged to other leftist splinter groups.

It is undoubtedly due to the political genius of Kristol that this club of intellectuals has managed to gain the financial resources and the momentum required to place its people in influential political positions and to infiltrate the universities and the media. As their motto they adopted the title of a book by the conservative writer Richard Weaver: *Ideas have Consequences*. With good reason.

By now this salon of intellectuals has become a powerful machine. It is financed by four right-wing foundations: the Sarah Scaife Foundation in Pittsburgh, the John M. Olin Foundation in New York, the Smith

Richardson Foundation in North Carolina, and the Lynde and Harry Bradley Foundation in Milwaukee. These "four sisters," as they are known, plus other foundations and supporters, notably Joseph Coors, the Colorado brewer ("The Rocky Mountain Legend"), provide the financial base for the big think tanks of the Right, such as the American Enterprise Institute and the Heritage Foundation in Washington who, together with others, have links to many university departments around the nation. It is this network of the neo-conservative movement that produces and supplies political ideas and strategies for Republican Presidents. It was Irving Kristol who managed to have Ronald Reagan adopt supply side economics, "Reaganomics" as it was also called. George Bush called it "voodoo economics" when he ran against Reagan, and before he adopted it himself — with the result that he destroyed the country. Movement institutes remain in close touch with their neo-conservative outposts inside the Government. Elliott Abrams, for example, the architect of the entire Central American policy of Ronald Reagan (the Contras in Nicaragua, the support of the military in El Salvador and Honduras, etc.)[23] literally belongs to the family: he married the daughter of Norman Podhoretz and Midge Decter, who, next to Kristol, are the two other big guns of the movement. Their son, John Podhoretz, is an editor at *Insight*, a weekly magazine of the *Washington Times*. The former

[23]In 1991, during the Iran-Contra investigation, the former Assistant Secretary of State for Inter-American Affairs pleaded guilty to charges of having withheld information from Congress about illegal and secret efforts to aid the Contras.

US ambassador to the United Nations, Jeane Kirkpatrick, is yet another member of the inner circle. And so is Irving Kristol's son, William Kristol, the chief of staff of Vice-President Dan Quayle.[24] Shortly after the election of Bush to the Presidency, the neocons decided to use the Vice-President as their outpost in the new Administration. They apparently hoped that, with their assistance, Dan Quayle would eventually no longer look like a clown and could then become their candidate for the presidential elections in 1996.

The cultural *Kampfblatt* of the neo-conservative movement is the *New Criterion*. Like other journals of the network, this periodical is subsidized by the "four sisters." Since its founding in 1982, until 1990, it received $2.5 million.[25] Its most faithful sponsor is the John M. Olin Foundation in New York. Every year it gives $100,000, and it was at the Olin Corporation's headquarters that the editorial offices were located in the beginning. The Olin Corporation ranks among the big American producers of ammunition, including poison gas. William Simon, the president of the Foundation, went around collecting money for the Contras, as did Elliott Abrams. The Foundation supports a large number of institutes and professors in American universities. Prominent among them are the University of Chicago's John M. Olin Center for the Theory and

[24]After the defeat of George Bush and Dan Quayle in 1992, William Kristol became the director of the Project for the Republican Future. The *New York Times* calls him "a leading Republican strategist" (Sept. 8, 1994, p. 1). He is also reported to be a supporter of Oliver North.

[25]By 1992, according to documents at the Foundation Center in New York, contributions to the *New Criterion* have amounted to at least $3.37 million.

Practice of Democracy of Allan Bloom and the John
M. Olin Program in the History of Political Culture
under François Furet.[26] The two leading figures of the
New Criterion are the publisher, Samuel Lipman ...

PB: ... who was at your conference?

HH: ... yes. Like me, he participated in the 1990
symposium *Culture and Democracy* at the University
of North Florida. He was not very happy about what I
said.

PB: He felt targeted ...

HH: In fact, he was distressed before I had even
reminded the audience that an intellectual from New
York, Samuel Lipman, had congratulated the Corcoran
Gallery in Washington, in the *New York Times,* for the
cancelation of the Mapplethorpe exhibition. When I
said (speaking of Jesse Helms), that "like Hitler, he
knows how to tap the *gesundes Volksempfinden,* the
so-called healthy, uncorrupted sense of the people,"
Lipman whistled loudly to make his disapproval
known. Spontaneously, he had allied himself with Jesse
Helms, for whom he otherwise has probably nothing
but contempt. It is fair to assume that, in his eyes, the
Senator lacks "distinction" (Lipman is a pianist and
music critic of *Commentary,* the political journal of his
friend Podhoretz).

[26]Jon Wiener, "The Olin Money Tree: Dollars for Neocon Scholars," *The
Nation,* New York, January 1, 1990, pp. 12, 13.

The other person is the chief editor of the *New Criterion*, Hilton Kramer, an art critic. In his editorial for the first issue, in 1982, Kramer announced that the mission of his journal is "to identify and uphold the standard of quality" which, in his view, is generally neglected. Solemnly he declared: "It is time to apply a new criterion to the discussion of our cultural life — a criterion of truth." The cause for the miserable state of current affairs are the "radical movements of the Sixties," which, according to him, have destroyed "the very notion of an independent high culture." It goes without saying that Mr Kramer is convinced that only he and his journal can guarantee the survival of "truth" and "capitalism." Two years after this manifesto, the defender of the "standard of quality" discovered a "Stalinist ethos" among American artists, critics, and institutions. Invoking Lionel Trilling, he vowed to pursue the "unmasking of Stalinist-colored liberal ideas." Among his examples of what, in his view, leads to "an eventual acquiescence in tyranny" he referred to two works of mine that dealt with the policies of President Reagan. As you can imagine, I take as a compliment his verdict that they are "devoid of any discernible artistic quality." This condemnation puts me in the good company of excellent artists such as Marcel Duchamp, Pollock, and others who have equally earned his contempt. ". . . Marcel Duchamp, whose actual accomplishment is so slender as to border at times on the non-existent . . . ," is typical of many similar comments he made on M.D. I also accept with pleasure his assessment that my works "undermine the very idea of art" — his own ideas, of course. Mr Kramer's claims

to act with "critical disinterestedness" and in the name of universal "truth" are rather staggering.[27] In a public debate, he told me that all Marxist-inspired interpretations of social life lead to tyranny (of course, he views himself as the infallible arbiter regarding what is Marxist-inspired). Faced with such Manicheanism there is nothing left to say. In a political climate where the word *liberal* (again in the American sense) already poses a problem, the "Marxist" label functions almost like the yellow star. The neo-conservatives are well aware of this — and make use of it.

PB: It's somewhat like the situation in France. Certain journalist-intellectuals united under the banner of opposition to the "ideas of 68" tried to create a climate in which all critical thought was identified with Marxism and was thus discredited. Evidently, the movement was reinforced by what happened in Eastern Europe (thanks to an identification of socialism with *Sovietism*).

It would be necessary to analyze how the continuous work of demolishing the figure of the intellectual that was being elaborated, in France, from Zola to Sartre has taken place; how a universe of evidence and undisputed theses, which are peddled in all good faith, has gradually been constituted; how journalists, condemned to the permanent renovation of their provisional admir-

[27]In a *60 Minutes* segment with the title "Yes . . . but is it art?" by Morley Safer, broadcast by CBS on September 19, 1993, Hilton Kramer served as expert witness. The program summarily ridiculed the work of Jean-Michel Basquiat, Jan Dibbets, Robert Gober, Anthony Gormley, Jeff Koons, Piero Manzoni, Gerhard Richter, Robert Ryman, Julian Schnabel, Félix González-Torres, Cy Twombly, and Christopher Wool. Mr Kramer, the art expert, weighed in: "Oh, it's largely a case of the emperor's clothes."

ations, have come to see intellectual life along the model of fashion (forgetting that, as much in science as in art, ruptures presuppose continuity). Owners short on thought and journalists or "intellectuals" short on power think of works of the spirit according to the categories chic/not chic, new/old-fashioned (and not true/false or original/banal, beautiful/ugly, etc.). To say that Dumézil's thesis on Indo-European societies is false is to take on the burden of proof. But one can also be content with saying: that is outmoded — that is to say not chic. And in Paris, not being chic is the kiss of death. One could even strengthen aesthetic-mundane condemnation with an ethical-political condemnation, as in the heyday of Stalinism, by saying that it is "Marxist" or, in the recent case of Dumézil, "Fascist."[28] Defamation, above all when orchestrated, is considerably more cost-efficient than refutation. In short, literary and artistic life has imported the logic of fashion or, even worse, as in the days of Stalinism or Maoism (often used together for a double condemnation), the logic of politics. Productions of the spirit, which are elaborated without political presuppositions in the universe of scientific or artistic discussion, are reduced to the level of politics, where they are easy to bring down — any fool can denounce a work that he does not understand as "reactionary" or "Marxist." It would be necessary to describe in detail, as you did for the group of intellectuals joined together around the *New Criterion*, the *networks* of intellectuals, gath-

[28]For a rigorous dismantling of the "proceedings" see Didier Eribon, *Faut-il brûler Dumézil?* (Flammarion, Paris, 1992).

ered around certain reviews, which have influence on intellectual life in France. The concerted action of conservative cliques gradually tends to impose an ideological climate, as you say, or a *doxa*, a whole set of evidence which is not discussed and which is at the foundation of all discussions. Once this *doxa* exists, it is terribly difficult to combat.

HH: But don't these people consider themselves intellectuals?

PB: Yes, unfortunately. They want to redefine the figure and function of the intellectual in their image, that is, to their size. They are Zolas who would publish manifestos like "J'accuse" without having written *L'Assomoir* or *Germinal,* or Sartres who would sign petitions or lead protest marches without having written *Being and Nothingness* or *Critique of Dialectical Reason.* They want television to give them a notoriety that previously only a whole, often obscure, life of research and work could give. They retain only the external signs and visible marks of the intellectual, the manifestos, the protests, public exhibitions. None of this, after all, would be important if they did not abandon the essential aspect of what defined the grandeur of the old-style intellectual — that is, critical dispositions based on independence from temporal demands and seductions and on adherence to the specific values of the literary or artistic field. Since they take a position on all current issues without a critical consciousness, without technical competence, and with-

out ethical conviction, they almost always go along with the established order.

HH: A good example of attacks on the critical sense, launched by the very people who think of themselves as infallible critics, is the cancellation of NEA grants for critics. Hilton Kramer clamored: in his view, young critics who appeared to him to be hostile to the policies of the US Government did not deserve grants (a remarkable idea for a person who claims to fight against the enemies of democracy). Samuel Lipman, a Reagan appointee on the National Arts Council, did the rest. The result of their joint intervention was the discontinuation of support for their less well-off colleagues while they continued to be sponsored by right-wing foundations.

It was not the first time that the pianist became active in Washington politics. At the beginning of the Reagan era, the Heritage Foundation prepared an action plan for the new Administration. In keeping with the times, the head of the team concerned with the future of the NEA and its counterpart, the National Endowment for the Humanities (NEH), was the executive director of the Olin Foundation, the political and economic base of the *New Criterion*. Samuel Lipman was given the job of reporting on the NEA. As he continues to do today, he proposed supporting only what he calls "serious art." In effect, that meant taking away funding from contemporary art and shifting it to established institutions that manage the tradition – the Western tradition, of course. It was a call *retour à l'ordre*, to an order that never existed.

PB: In truth, what they seek, in different ways, is the destruction of critical thinkers. One of their favorite weapons is, obviously, to identify intellectuals with and contaminate them by Marxism.

HH: A democratic society must promote critical thinking, including a constant critique of itself. Without it, democracy will not survive.

PB: One of the areas where everything you are describing is seen very clearly is that of the social sciences. Sociologists and historians are paid to produce a scientific analysis of the functioning of the social world. As French philosopher of science Gaston Bachelard says, "there is no science but of that which is hidden." That is, from the moment there is a science of the social world, it inevitably reveals that which is hidden, and in particular that which the dominant do not want to see unveiled.

That is what we are in the process of doing, in a doubtlessly partial and, in a sense, particular manner. Patronage is a subtle form of domination that acts thanks to the fact that it is not perceived as such. All forms of symbolic domination operate on the basis of misrecognition, that is, with the complicity of those who are subjected to them. Even if it does nothing but describe facts and effects and bring mechanisms to light (such as those that create symbolic violence), science exerts a critical effect. Therefore, the very existence of social science is unbearable. All authoritarian regimes have suppressed sociology from the outset. What they

want is an applied sociology that can help manage conflicts and contradictions and rationalize domination.

One of the problems for the social sciences is obtaining the resources necessary for research (sociology is expensive ...) without becoming alienated, without sacrificing their autonomy. Since the need for autonomy is not clearly perceived and considered, since sociologists do not think collectively, an increasingly important part of social science gradually tends to be transformed into applied science which, directly or indirectly, finds itself at the service of extra-scientific functions. Erving Goffman once told me that we should write a manifesto together against abusive uses of the social sciences. I responded, without much reflection, that our inventions were not all that dangerous ... In fact, the social sciences have invented all sorts of techniques (surveys, for example) which are used as instruments of domination. We can still consider ourselves fortunate if we manage to avoid having our techniques and results used in the wrong way. And we cannot hope to ensure the (active or passive) complicity of journalists, as you manage to do, in order to deploy all the critical force inscribed in our discoveries.

Defense of the West and the return of absolutism

But, to come to another point, the defenders of culture we are talking about also see themselves as defenders of the West and of Western culture. It is not by chance

that their attacks focus on the relativism they impute to the social sciences, confusing a basic methodological precept with a nihilistic demolition of all cultural values.

HH: Yes, the problems and the terms in which they are cast are practically the same in the United States. One argues in the name of Western "civilization" (in the exclusive sense of the nineteenth century). The conservatives, spearheaded by neo-conservative intellectuals, rage against attempts (usually rather timid ones at that) at fostering multicultural attitudes and introducing multicultural programs in schools, universities, and the nation. They understand quite correctly that the recognition of values, truths, and cultures different from their own not only constitutes a menace to the base of their system of beliefs, but it also threatens their control of power.

The United States has always been a country of immigration. According to the 1990 census, 30 percent of the population does not have European roots. Today these non-European Americans become more conscious of their different traditions, and they recognize more acutely that neither their achievements nor their enslavement have been acknowledged. They demand the respect they deserve. Even a cursory examination of "Western civilization" leads to the discovery that it is, in fact, a multicultural amalgam with many contributions from other parts of the world. To claim that "civilization" is white rather than mulatto is tantamount to ideological, if not racist, censorship. History demonstrates that "we" (whites) have benefited from

the ideas and discoveries of the "others." The world would profit from the free exchange of symbolic goods. Separatism offers the illusion of strength, but in reality it mortgages the future.

Linked to the debate over multiculturalism are demands for equality and respect for women, gays, and lesbians. Inevitably, the problems of ethnic and sexual identity are political. They constitute a threat to privileges which, until now, were not recognized as such. The calls for freedom, equality, and fraternity (today one should say solidarity rather than fraternity) are far from being satisfied. It did not surprise me that seeing them spelled out in Arab calligraphy rather than Roman letters, as I did for a work in France, was not appreciated. The guarantee of "the pursuit of happiness" in the American Constitution is not faring better. Today's battles hardly differ from those fought two hundred years ago.

The conservative strategy for discrediting the contemporary cultural revolution is to seize upon caricatural examples in order to project the image of a horde of barbarians who can hardly wait to tear down the foundations of civilization. Bankrolled by the foundations of the Right, the agitators have cleverly muddled things by co-opting the derogatory abbreviation "p.c." (politically correct). The Left had used the term ironically, and even with contempt, to refer to humorless fundamentalists in its own ranks. Today, the conservative campaign brands all attempts to correct social inequalities as "p.c." and even relates them to McCarthyism. And the press falls for it. In the present hysteria, it is forgotten that conservatives created

Calligraphy, 1989

Proposal for the Cour d'Honneur of the Palais Bourbon in Paris. Architectural model for a competition initiated by the president of the National Assembly (French Parliament) to create a permanent sculpture commemorating the bicentennial of the Assembly's founding in 1789.
Photographs by Fred Scruton.

The project covers the entire area of the Cour d'Honneur of the Palais Bourbon.

A cone, 4.3 m (14 feet) high and 12 m (39 feet) in diameter, occupies the circular area in the upper part of the court, the so-called horseshoe, which has traditionally been planted with flowers. Although giving the impression of a "mountain" towering at the far end of the court, the height of the cone is limited, in order to block neither the view of the peristyle behind nor the view from the bronze door toward the entrance gate of the Cour d'Honneur.

Irregularly shaped rocks are fitted together and polished so that they form a smooth and perfectly conical surface supported by a hollow cone of concrete underneath. The cone is a shape reminiscent of the revolutionary architecture of Boullée and the spirit of the Enlightenment which inspired the Declaration of the Rights of Man.

The number of rocks in the cone equals the number of districts from which the members of the Assembly are elected. The deputies are to be invited to provide a rock from the region that they represent, so as to make the cone a symbol of the responsibility and collective power of the legislature.

Gilded calligraphic signs in relief are mounted on the smooth rock surface of the cone. They spell, in Arabic, the words: liberty, equality, and fraternity.

The translation of these words into Arabic suggests that, in contrast to the relatively homogenous French population of 1789, France today is a multiracial and a multicultural society. The promise of freedom, equality, and fraternity is not yet fulfilled, especially for the contemporary Third Estate comprising, among other groups, the Muslim population of France, even if one finds these words inscribed on the facades of numerous public buildings. Spelling out the three Republican principles in Arabic calligraphy is to provoke their revival as a guide for every act of the National Assembly.

From the top of the cone, a jet of water spurts upwards to a height of 15 m, and then falls back onto the cone. Additional water wells up from the cone's interior, spilling out of its top, and runs down the

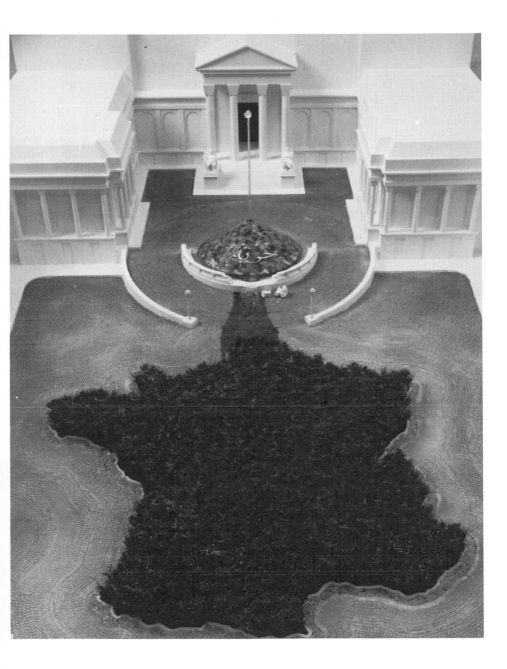

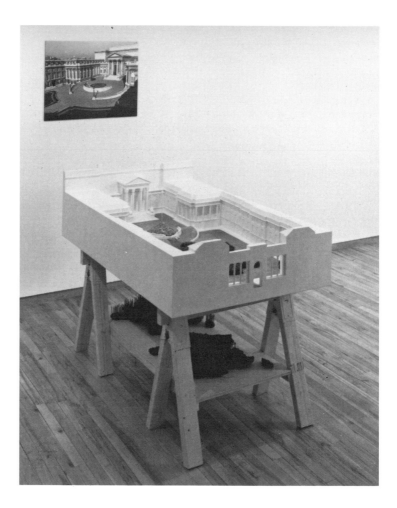

surface like lava from a volcano. Its flow is broken by the raised Arabic letters in its path, leading to a complex, light-reflecting runoff.

The water collects in a narrow trough around the cone's perimeter which slopes toward the center of the balustrade around the horseshoe. Through a breach in the balustrade that its force seems to have broken, the water rushes down onto the pavement of the court underneath. Chunks of the broken balustrade, an element of classical architecture associated with the *ancien régime*, litter the ground. Due to a grade in the terrain, the water flows freely toward the center of the court. The main court is occupied by a large, irregularly shaped area. Seen from the upper part of the horseshoe, it is recognizable as the map of France — with Corsica in a corner of the main court (the overseas possessions could be represented by small "islands" in the court of the nearby Hôtel de Lassay).

On these map areas, crops common to French farming are grown in a four-year cycle: one year wheat, corn, or rape; the second year cabbage or sunflowers; the third year beans, peas, or potatoes. In the fourth year, the field would lie fallow. Weeds would be left to grow naturally so that the soil can recover for a new cycle. In the case of crops grown in rows, the configuration of these rows follows con-

centrically, like a ripple, the outline of the map of France towards the center.

The planting should be cared for consistent with normal farming procedures, not with the attention reserved for formal gardening. The alternating crops are to be seen in contrast to the manicured gardening style of Versailles, which symbolically imposed the royal will even on nature. The presently hidden vents from the parking garage below the court are exposed to accentuate the less "romantic" contribution of contemporary technology.

The "legislative waters" coming down from the cone and through the broken balustrade encircle France. They flow down a shallow trough with a grade toward the gate of the court, where they disappear into an opening in the ground. Corresponding to the "ripple" of the rows of plantings, the paving stones of the court echo the outline of the map of France outward to the sidewalks on the perimeter, while the paving stones around the cone form concentric circles.

A pumping mechanism for the supply of the water jet and the "lava" is installed inside the cone or, invisible to the viewer, in an adjacent location. An additional pump supplies the water from underground for the stream encircling Corsica. The entire volume of water is recycled.

McCarthyism and that they don't hesitate to use the master's techniques today. President Bush, always courting the right wing of his party, adopted the strategy in a commencement address in 1991 at the University of Michigan. As they did during the presidential election of 1988, conservatives, without fail, resort to racist, misogynist, and homophobic innuendo.

PB: Yes, it is a very predictable combination. We have the equivalent in France, but in the much more disguised form of a critique of cultural relativism. This debate, as old as anthropology, has resurfaced through people who see relativism as a threat to cultural monotheism. It is beyond our scope to tackle the question of relativism and absolutism here, even more so to settle it once and for all, especially since it is poorly stated (absolutism is clearly based on the absolutization and the naturalization of a historical culture, and is thus linked to the contingent conditions of its emergence). I will say only that there is no absolute, universal point of view, either in the universe of different societies, contemporary or from different epochs, or even within a single society. There are, however, people who fight to impose their particular point of view as the universal point of view, and who, to that end, attempt to universalize their particular point of view (through which is affirmed, moreover, their recognition of the universal, quite often within the logic of the tribute that vice renders to virtue, but which really does contribute to the progress of the universal). In fact, it seems to me that the journalistic-mundane critique of cultural relativism telescopes two oppositions: between high

and low culture on the one hand and between the West and the rest of the world or, more precisely, the East on the other. In the United States it is likely that these positions are held by extreme right-wing neo-conservatives. In France, they are held even by some people who consider themselves on the Left, often by small shareholders of cultural action, the "white trash" of culture, who, not possessing much culture, are particularly attached to it and who, like small shopkeepers threatened by economic change, fall into an extremely violent sort of cultural *poujadisme.*[29]

HH: A number of years ago I participated in a symposium with the title "Aesthetic Value: The Effect of the Market on the Meaning and Significance of Art." Among the panelists was Philippe de Montebello, the director of the Metropolitan Museum of Art. He was incensed over an article in the *New York Times* by Michael Brenson. In this article, Brenson (he is no longer writing for the paper) had proposed rethinking the question of evaluation and the criteria of quality in regard to works by artists who, like women and artists from non-European backgrounds, have until now been left outside the traditional circuit of Western culture. For the esthete of the Metropolitan the idea that an absolute judgment does not exist constituted an "ultimate sacrilege." Full of conviction and shaking with

[29]After Pierre Poujade, French politician who founded, in 1954, the Union de défense des commerçants et artisans de France (UDCA) in order to defend sectoral interests. *Poujadisme* refers to a short-sighted defense of narrowly defined interests — trans.

emotion, he exclaimed: "There has to be somewhere an absolute. . . . Just as I believe there has to be a God."

PB: I had been speaking of cultural monotheism . . . We could also speak of the restoration of absolutism . . .

HH: The question of whether it is possible to use constant criteria to evaluate works from Africa, India, and other cultures in his museum, he answered yes, "if you are, and I'm going to use another unpopular term, cultivated." Such arrogance can perhaps be explained by the fear that recognition of the contingency of all judgment puts into question enormous investments, symbolic investments as much as financial investments – and social rank. The defenders of "disinterested" and absolute judgment skillfully muddle the debate by painting their adversaries as people who have abdicated *all* judgment, advocates of the "anything goes." Like everybody else, I use criteria when I look at objects in the collection of the Metropolitan Museum. Coming more or less from the same cultural background as this manager of symbolic power, I probably agree with him in many instances. In others, however, my "habitus" (one of your terms I find useful for this discussion) would undoubtedly put me on the opposite side of his universe of significations, taste, and ideological preferences.

The history of centuries of collective reception, like that of my own experience, does not permit me to believe in the absolute. As I use my judgment in art, always mindful that my criteria lack universal validity, so my ideas and actions in other areas are guided by a

system of values. My support for multiculturalism, for example, does not keep me from rejecting fundamentalism, no matter whether Christian, Islamic, Jewish, or any other. I am against those who condemn multiculturalism, but I am equally opposed to those who, in the name of multiculturalism, suppress freedom of expression.

PB: Behind the defense of culture is hidden the defense of the West against Eastern "barbarism" and all the threats it is reputed to pose to European values and the European way of life.

HH: I believe that in the United States we have entered a period of deep polarization. The 1980s, that decade of the "in" and "out" (equivalent to your "chic" and "non-chic"), are bankrupt. We no longer have the luxury of looking at things in terms of fashion. Unpleasant realities are catching up with us. People begin to understand that vital things are in question — their standard of living is at stake, if not more.

Sometimes I ask myself whether intellectuals have, in fact, a romantic notion of their profession. The failure of the cultural revolution of 1968 may have been such a traumatic experience for them that they are incapable of analyzing what role they played then and what role they play today. I believe that many French intellectuals on the Left have been weakened by a sense of defeat. It may have been further accentuated, at the time, by their disgust over the repression of the revolution in Czechoslovakia by the very powers some of them still believed to be their natural allies. And

then they began to discover that intelligent people also existed outside their small world, even though, until then, they had not taken them seriously: top executives in business, the media, and politics, people who seem to succeed. Full of admiration for their efficacy and fascinated by the apparent success of individuals who do not spend their time with critical questions, these intellectuals begin to fall into line.

PB: You are describing the Saint-Simon Club...

HH: To compensate for their sense of inferiority and their disillusion with the reality of the countries that had called themselves "socialist," many of them defected. They are now part of management. I readily concede that this scenario is rather speculative and drawn by somebody who doesn't have an intimate knowledge of the situation in France.

PB: No, it's not far off. I think the shock caused by the movement of May 1968 had a quite determinant effect. Strangely, this symbolic revolution which did not have great political consequences left deep marks on the spirit, particularly among professors, from Los Angeles to Berlin ... Just as one cannot understand the thought of the end of the last century — from Durkheim to Le Bon and to the conservative philosophers inspired by them — if one forgets the Commune, so one cannot understand the rebirth of conservative and neo-conservative thought, in the United States and in France, and the appearance of a veritable international conservative movement, with its networks, its journals,

its foundations, and its associations, if one does not keep in mind the trauma caused by the movement of May 1968. That collective trauma threw back into the most bitter conservatism, notably in questions of art and culture, academics — sometimes even "liberals" and progressives — who felt that their ultimate values as men of culture were threatened and who identified with mediocre pleas for the preservation and restoration of culture, such as those of Harold Bloom, among so many others.

The veritable campaign unleashed in the United States in recent years against French thinkers, whether they are taken as a block, according to the logic of political amalgamation, as in the book by Tony Judt,[30] which is a web of simplistic truisms, or attacked individually, is based on the political anxiety, in the broadest sense of the term, provoked by these thinkers, who are extremely different from each other, but who are impelled by the same critical, anti-institutional temperament. But I suspect that the campaign also serves the more or less unconscious national (or nationalist) interests of certain American intellectuals for whom "political" affinities (often based on the homology of university positions) assure the collaboration of French intellectuals. What is certain is that, despite appearances, these international exchanges and the whole circuit of laudatory reviews, invitations, etc. in which they express themselves do nothing to advance the internationalism or, if you would prefer a more neutral

[30]Tony Judt, *Past Imperfect: French Intellectuals, 1944–1956* (University of California Press, Berkeley and Los Angeles, 1993).

term, the universalism toward which all intellectuals should struggle.

In the state's noose

But you were just talking about the "intellectuals" who, to escape from disenchantment in face of the failure of so-called socialist regimes, went over to the side of the establishment (this is an optimistic hypothesis: there is also the ambition for power, which permits them to exert, by other means, an influence they could not exert solely with their intellectual weapons). Since the 1960s, certain intellectuals — on the whole sociologists or the economists influenced by the American model — have exalted the figure of the expert manager or the administrative technocrat against the previously dominant image of the critical intellectual, particularly that of Sartre. Strangely, it was no doubt the arrival of the socialists in power that dealt a decisive blow to that image. Socialist power has given rise to its own small-minded, court intellectuals who, from colloquium to commission, have taken the front stage, blocking or combating the work of those who have continued to resist in their research on all orders.

HH: There is, perhaps, an insoluble conflict. No organization, certainly not a complex society like ours, can survive without managers. I am sure we gain by the presence of intellectuals in managerial positions.

But I am also fully aware that the goal of management is to assure a smooth operation rather than reflection and critique. These are contradictory responsibilities. I have witnessed the radical and, no doubt, inevitable change in people from the art world, when they move from the critique to the curating of exhibitions or the management of institutions.

PB: Through the discrediting — indeed, the demolition — of the critical intellectual, what is at stake is the neutralization of every form of counter-power. We are in the way. People who have the presumption to oppose, individually or collectively, the sacred imperatives of the administration are quite unbearable.

And here we find another antinomy or, at least, a contradiction that is very difficult to overcome. Research activities, in art as well as science, need the state to exist. To the extent that, *grosso modo*, the value of works is negatively correlated with the size of their market, cultural businesses can only exist and subsist thanks to public funds. Cultural radio stations or television channels, museums, all the institutions that offer "high culture," as the *neocons* say, exist only by virtue of public funds — that is, as exceptions to the law of the market made possible by the action of the state, which alone is in a position to assure the existence of a culture without a market. We cannot leave cultural production to the risks of the marketplace or the whims of a wealthy patron.

HH: Here is a little anecdote: The Busch-Reisinger Museum of Harvard University, a museum that special-

izes in German art, now has a "Daimler-Benz Curator." He (it is a he) holds a chair underwritten by Mercedes. It is unthinkable for this museum to exhibit my work.

PB: By definition, the state brings a solution that is not logical (there is none), but sociological, to the paradox of the *Free Rider*, so dear to neoclassical economists. Only the state is in a position to say, with the chances of being heard and obeyed: whether you ride the bus or not, whether you go to the hospital or not, whether you are black or white, Christian or Muslim, you must pay so that there can be buses, schools, and hospitals that are open to blacks and whites, to Christians and Muslims. Radical liberalism is evidently the death of free cultural production because censorship is exerted through money. If, for example, I had to find sponsors to finance my research, I would have a hard time. As would you, if you had to seek support from Mercedes or Cartier. These examples are obviously a bit crude, but I think that they are important because the stakes can be seen most clearly in extreme cases.

HH: There is an entirely different tradition in the United States. Almost all cultural institutions are private and depend on the good graces of donors and, more recently, on sponsors. What frightens me is that Europe is beginning to follow the American model. Institutions which were liberated from the tutelage of princes and the Church now fall more and more under the control of corporations. Obviously, these corporations are only to serve the interests of their shareholders — this is what they are set up for. The de facto

privatization of cultural institutions has a terrible price. Practically speaking, the republic, the *res publica* — that is, the public cause — is being abandoned. Even though the sponsors cover only a small part of the cost, it is they who really determine the program. Mr de Montebello, who is certainly an expert in these matters, admitted once that "it's an inherent, insidious, hidden form of censorship."[31] It is difficult to reverse the situation once the state has abdicated and the institutions have become dependent on the sponsors. Even though in the end — that is, at the level of the national budget — the taxpayers still pay the bills, the institutions, focusing on their immediate and individual problems, see only financial relief. More and more, they are getting used to limitations on the content of their programming. Management prevails. Nevertheless, the chief of Cartier implicitly warned us that the sponsors' enthusiasm is not guaranteed for ever. In an interview he explained: "Culture is in fashion, all the better. As long as it lasts, we should use it."[32] It would be naive to think that the state will resume its responsibilities for culture when the Cartiers of the world have lost interest.

PB: In fact, and it is here that we find the antinomy, there are a certain number of conditions for the existence of a culture with a critical perspective that can only by assured by the state. In short, we should expect (and even demand) from the state the instruments of

[31]"A Word from our Sponsor," *Newsweek*, November 25, 1985, p. 98.
[32]Perrin, "Le mécénat français," p. 74.

freedom from economic and political powers — that is, from the state itself. When the state begins to think and to act in terms of the logic of profitability and return in relation to hospitals, schools, radios, televisions, museums, or laboratories, the greatest achievements of humanity are threatened: everything that pertains to the order of the universal — that is, to the general interest, of which the state, whether one likes it or not, is the official guarantor.

That is why artists, writers, and scholars, who hold in trust some of the most exceptional accomplishments of human history, must learn to use against the state the freedom that the state assures them. They must work simultaneously, without scruples or a guilty conscience, to increase the state's involvement as well as their vigilance in relation to the state's influence. For example, with regard to state support of cultural production, it is necessary to struggle both for the increase of support for noncommercial cultural enterprises as well as for greater controls on the use of that assistance; for more support, but against the increasingly widespread tendency of measuring the value of cultural products by the size of the public, thus simply condemning, as occurs with television, works without a public. We need greater controls on the use of state assistance, because if commercial success does not guarantee scientific or artistic value, the absence of commercial success does not either, but we should not exclude a priori the possibility that among books that are difficult to produce without subvention, there may be some that do not deserve to be published.

But, in a more general sense, it is necessary to avoid

allowing state patronage, obeying a logic quite similar to that of private patronage, to permit the holders of state power to create a clientele for themselves (as we have recently seen in the purchase of paintings or in the attribution of advances on film receipts) or even a veritable court of "writers," "artists," and "researchers." It is only by reinforcing both state assistance and controls on the uses of that assistance, and in particular on the private misuse of public funds, that we can practically escape the alternative of statism and liberalism in which the ideologues of liberalism want to enclose us.

HH: Yes, that's where we have a very important responsibility.

PB: Unfortunately, citizens and intellectuals are not prepared for this freedom in relation to the state, doubtless because they expect too much from it, in personal terms: careers, commissions, decorations, lots of things which are often quite pathetic, through which they hold the state dear and are held by the state. And besides, there is the law (one could call it the Zhdanov law) which says that the weaker a cultural producer is, the less he is recognized according to the specific laws of his universe, and the more he needs external powers, the more he is disposed to appeal to those powers (those of the Church, the party, of money or the state, according to the specific place and time) in order to impose himself in his universe. Robert Darnton has rendered a great service to truly critical thought by recalling that a large proportion of French revolution-

aries emerged from the bohemia of writers and failed intellectuals.[33] Marat was a very poor intellectual who sent some very good intellectuals to the guillotine. State patronage always risks favoring the mediocre, who are always more docile. In 1848, a government on the Left was in power. The brother of Louis Blanc was Minister of Culture, and a conventional painter was given the responsibility for painting the Republic's portrait . . . More generally, it is well known that progressive political ideas do not automatically go hand in hand with aesthetic radicalism, for very evident sociological reasons. A truly critical form of thought should begin with a critique of the more or less unconscious economic and social bases of critical thought itself. As you have said, very often a truly critical form of thought is also led to oppose those who veil critiques of conservative thought or practices with justifications or who adopt critical position-takings only because they are not in a position (primarily for lack of competence) to occupy positions normally associated with conservatism.

HH: No doubt, public funds are always at risk of being used to support mediocrity or to keep an art bureaucrat on the payroll. When it comes to public commissions, an area terribly exposed to political pressures, there are, in fact, a lot of horrific examples. But if we look at private commissions and acquisitions, the situation is not better, perhaps even worse. The works

[33]Robert Darnton, *Bohème littéraire et Révolution. Le monde des livres au XVIIIe siècle* (Gallimard-Seuil, Paris, 1983), coll. "Hautes études."

in the "Degenerate Art" exhibition that the Nazis organized came exclusively from public collections. This means that in spite of the Kaiser's hostility and the aversion of the authorities that followed him in 1918, who, like him, knew nothing about art, the directors of German museums had acquired a fairly large number of important works of the avant-garde of their time. Let me give you another example: a comparison of the contemporary acquisitions of the Museum of Modern Art in New York (which depends, as a private institution, mostly on donations) with those of the Centre Pompidou shows that the French civil servants could allow themselves to put together, with public funds, a more impressive collection of "risky" works (daring in terms of the market, "morality," and ideology) than MOMA.

PB: A public system leaves a very large margin of freedom, but one must still make use of it.

Philosophers love to pose the question of the freedom of the state-employed philosophy professor. In fact, it is very important for there to be philosophy professors appointed by the state, but on the condition that they truly know how to make use of the freedom associated with the fact that they hold a position guaranteed by the state, including, eventually, standing up against the state or, more precisely, against the state's thought. But they really don't do that, in any case much less than they believe . . . And clever state authorities know very well how to manipulate artists, inviting them to a garden party at the Élysée, for example. It nonetheless remains true that when you

have a courageous curator, he can buy your works. Whereas if it was financed by private enterprise, he cannot.

HH: The new curator of the *Galeries Contemporaines* at the Centre Pompidou may need more courage than his predecessors: he used to be a curator at the Cartier Foundation.

PB: What is the curator's status in Graz? Is there a state curator?

HH: The situation in Graz is rather complex. Since 1968, every fall a culture festival has been held in Graz, the *Steirischer Herbst* (Styrian Autumn). It is financed by the city of Graz, the province of Styria, and by the Austrian government in Vienna.

PB: That is an occasional event, not a permanent structure.

HH: Werner Fenz, who curated the visual arts section of the festival during my participation, is a curator of the *Neue Galerie*, the small municipal museum for modern art in Graz.

PB: He is oddly courageous . . .

HH: Absolutely. Fortunately he was not alone. For the twentieth anniversary of the festival the organizers decided to commemorate another anniversary, that of the *Anschluss*, Hitler's annexation of Austria in 1938. Sixteen artists were invited to produce works for a

temporary installation in public places that had played a significant role under the Nazi regime. Werner Fenz explained his concept with admirable clarity: "*Points of Reference* [title of the exhibition] aims to challenge artists to confront history, politics, and society, and thus regain intellectual territory which has been surrendered to everyday indifference in a tactical retreat, a retreat that has been continual, unconscious and manipulated." I proposed concealing the statue of the Virgin Mary, in the center of town, under an obelisk with Nazi insignia, as the Nazis had done in 1938, and adding an account of those who died under their regime in Styria. When I presented the proposal, I was absolutely convinced it would not be possible to realize it. However, I did not want to participate in the exhibition except with this project. The people in charge could easily have rejected it by reasoning that its realization would exceed the limits of the budget. In light of the region's still sizable number of Nazi sympathizers, they could have rejected it also for reasons of public safety. They could even have said it should not be done out of respect for the Virgin, as a newspaper argued after my memorial to the victims of Nazism had been firebombed. In spite of all these possible arguments and obstacles, the project was carried out. The city under Social-Democratic leadership and the Conservative provincial government collaborated. As I hoped, among the people of Graz, the memorial served as a catalyst for historical awareness. It is always assumed that censorship and self-censorship exist wherever one turns — and, of course, they do. However, if one tests the limits, sometimes one discovers that there are holes in the wall, that one

And You Were Victorious After All, 1988

Temporary installation during *Bezugspunkte 38/88*, an exhibition organized by the Steirischer Herbst (Styrian Fall Festival), October 15–November 8, 1988, in Graz, Austria. Curator of the exhibition: Werner Fenz. Photograph from 1938: Bild- und Tonarchiv, Landesmuseum Joanneum, Graz. Photograph of the destroyed obelisk: Angelika Gradwohl, Graz.

One of Graz's older monuments, the *Mariensäule* (Column of the Virgin Mary), rises in a square at the south end of Herrengasse, the most prominent street in Graz. Erected late in the seventeenth century to commemorate the victory over the Turks, it is a fluted column on a massive base, crowned by a gilded statue of the Virgin astride a crescent moon. It has been a popular landmark ever since.

When Hitler conferred on Graz the honorary title *Stadt der Volkserhebung* (City of the People's Insurrection), the ceremony on July 25, 1938 was held at the foot of the *Mariensäule*. Graz had earned the title for having been the foremost Nazi bastion in Austria. Some weeks before the *Anschluss*, thousands of Nazis paraded down Herrengasse in a torchlit procession, the swastika flag hanging from the balcony of city hall, and Jewish shop windows were smashed.

For the 1938 celebration, the *Mariensäule* was hidden under an enormous obelisk, draped in red fabric, and emblazoned with the Nazi insignia and the inscription "*UND IHR HABT DOCH GESIEGT*" (And you were victorious after all). This claim of an ultimate triumph referred to the failed putsch in Vienna on July 25, 1934, four years earlier, during which Nazis murdered the Austro-Fascist chancellor, Dr Engelbert Dollfus.

Guided by photos from the era of its transformation into a triumphal Nazi column, the ensemble was rebuilt in 1988 for the Styrian Fall Festival. The reconstruction differed from the original only in an inscription around the base that gave a list of the vanquished of Styria.

During the night of November 2, a week before the end of the exhibition, the memorial to Nazi victims in Styria was firebombed. Even though firemen were able to extinguish the flames rapidly, much of the fabric and the top of the obelisk burned, and the statue of the Virgin was severely damaged.

The local and national press, as well as the German press, reported the firebombing, some likening it to the hostile reactions to the Burgtheater's premiere of *Der Heldenplatz* by the Austrian playwright Thomas Bernhard. Many headlines referred to the ruin of the *Mahnmal* (memorial) as *Schandmal* (monument of shame), condemning the arson and its suspected political motivation. An exception was the *Neue Kronen Zeitung*, the

78

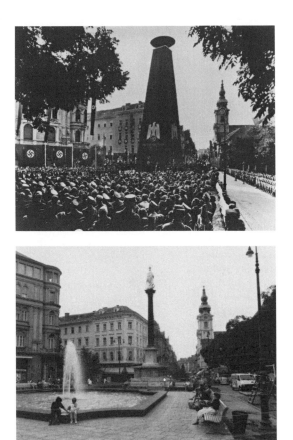

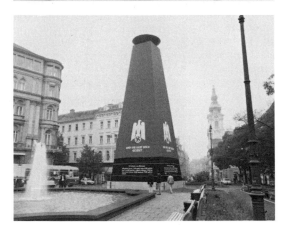

largest and most conservative Austrian daily tabloid, which had been the strongest supporter of Kurt Waldheim. The Graz editor used the occasion to attack the leaders of the Catholic Church for having permitted the encasement of the *Mariensäule* and the politicians for having squandered tax money on such a shameful project.

Richard Kriesche, an artist from Graz, called for a 15-minute silent demonstration at the ruin at noon on the following Saturday. About a hundred people belonging to the local art community came and discussed the meaning of the event with the crowd of Saturday shoppers that had gathered around. For days afterwards, inspired by the *Katholische Aktion* (a lay apostolate), leftist politicians, students, and others left flowers and lit candles by night at the foot of the burned obelisk.

Thanks to a police sketch and the descriptions given by two people who had seen the arsonist from afar, he was arrested out of the crowd of bystanders lining the streets of Graz during the silent march commemorating *Kristallnacht*. He was identified as an unemployed, 36-year-old man who had been moving in neo-Nazi circles. The instigator of the firebombing was also arrested. He was a well-known 67-year-old Nazi. They were both sentenced to prison terms.

AND YOU WERE VICTORIOUS AFTER ALL

The vanquished of Styria:
300 Gypsies killed, 2,500 Jews killed, 8,000 political prisoners killed or died in captivity, 9,000 civilians killed during the war. 1,200 missing, 27,900 soldiers killed.

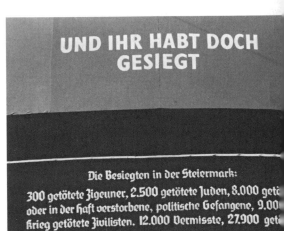

80

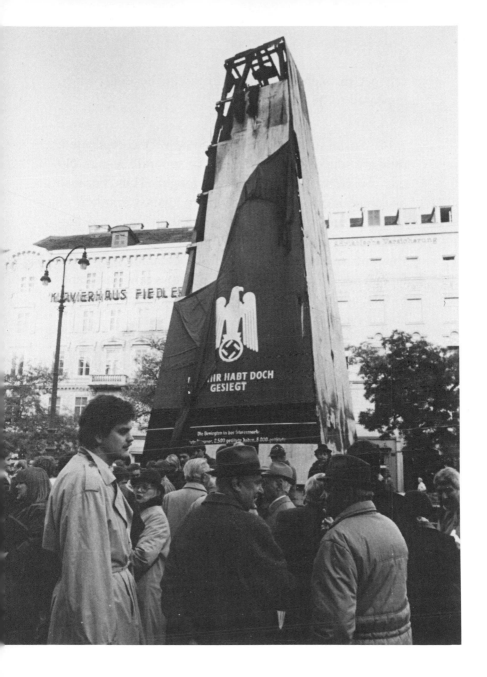

can get through, and that things can be done which appeared to be impossible.

PB: Social universes have become very complicated: they are sets of very complex and separate games. No one can control everything any longer. Thus, because of competition — of one ministry against another, of one department against another, within the same universe or between universes — some things can happen. But with an enormous waste ... It depends very often on one person, but a person who knows how and wants to take advantage of the "game" that social structures always entail.

HH: It's due to a particular person or to unusual circumstances like the ones I encountered in Berlin after the fall of the wall and before the unification of the city. If one doesn't try, nothing happens. If one succeeds, it sets a precedent on which one can build.

PB: To connect that to what we have been saying about the intellectual "climate," we can suppose that since people have the tendency to forego undertaking an action that does not have a certain chance of success, the climate that tends to discredit critical intellectuals and to lower their estimate of their chances of doing things successfully contributes to a form of self-censorship or, worse, a feeling of demoralization and demobilization. That is why, things being as they are, actions like yours are invaluable. To borrow an expression from

Max Weber, they have the value of "exemplary prophecy."

HH: In the Graz piece, as in the ones in Berlin and on Königsplatz in Munich, I did not really supply new information. Through others, though — for example, the work on the links between Philip Morris and Senator Helms — I disclose hitherto unknown information, which makes them newsworthy. During my research on the tricks of the cigarette-maker who tells the world that "It takes art to make a company great," I stumbled on an explosive piece of information: the sponsor of the Bill of Rights doesn't only fund the election campaigns of Jesse Helms, as I suspected; in addition, the cowboys at Philip Morris gave $200,000 for a museum that is to honor him and propagate the "American values" he represents. I incorporated this bit of news in a collage, a facsimile of a Picasso collage that was part of the Philip Morris-sponsored Braque-Picasso exhibition at the Museum of Modern Art in New York. I replaced the newspaper clippings of the original with excerpts from newspapers of today. The *New York Times* and other papers reported extensively on my discovery, and later on also the embarrassed responses of the company's press officers. In protest against Philip Morris's support for the enemy of art and gays, a number of artists withdrew from events sponsored by Philip Morris. *Act Up*, the gay activist organization, called for an international boycott of *Marlboro* and *Miller* beer (also a Philip Morris product). The effect of this boycott was felt as far away as Berlin. In the end, the Helms sponsor decided to give money for

the fight against AIDS — and to publicize this act of "generosity."

PB: You prove that a person, almost alone, can produce immense effects by disrupting the game and destroying the rules, often through scandal, the instrument par excellence of symbolic action. At the very least, you show that we are not condemned to choosing between collective action, mass protests, or commitment to a single party or course of action, and individual apathy, resignation, and submission.

HH: It certainly helped that Jesse Helms has few friends in the New York media world. The revelation also coincided with the big debate on the dangers of smoking in the United States. Even the Secretary of Health in Washington has accused Philip Morris of being a "merchant of death." The audacity of parading in the glory of the Bill of Rights turned into a boomerang.

A politics of form

PB: At this point, it would seem important to reflect on the fact that the process of autonomization of the artistic world (in relation to patrons, academies, states, etc.) is accompanied by a renunciation of certain functions, particularly political functions. One of the effects that you produce consists in reintroducing those func-

tions. In other words, you extend the freedom that has been acquired by artists throughout history, and which was limited to form, to other functions. This leads to the problem of the perception of your works. There are those who are interested in the form and who do not see the critical function, and those who are interested in the critical function and do not see the form, so in reality the work's aesthetic necessity has to do with the fact that you say things, but in a form that is equally necessary, and just as subversive, as what you say.

HH: I believe the public for what we call art is rarely homogeneous. There is always tension between people who are, above all, interested in *what* is "told" and those who focus primarily on the *how*. Neither of them can fully comprehend and appreciate a work of art. "Form" speaks, and "content" is inscribed in "form." The whole is inevitably imbued with ideological significations. That's also true for my work. There are those who are attracted by the subject and the information . . .

PB: The message.

HH: . . . explicit or implicit. They may find themselves reinforced in their opinions, recognizing that they are not alone in thinking what they think. It is pleasurable to come across things that help us better articulate vague notions we have and to give them a more precise form. Therefore, preaching to the converted, as one says, is not a total waste of time. A good

Cowboy with Cigarette, 1990

Collage on paper, charcoal and ink. 94 × 80 × 6 cm (37 × 31 × 21¼ inches) (including frame). First exhibition: John Weber Gallery, New York, 1990. Photographs by Fred Scruton.

The collage includes texts drawn from the following sources:

— Philip J. Hilts, "Smoking's Cost to Society is $52 billion a year, Federal Study Says," *New York Times*, February 21, 1990.

— Nick Raco, "Tobacco Companies' Gifts to the Arts: A Proper Way to Subsidize Culture?" *New York Times*, March 8, 1987.

— "The Latin American Spirit: Art and Artists in the United States, 1920–1970," page 58 of a 1989 internal document of the Philip Morris company, giving an overview of cultural events sponsored by Philip Morris.

— "Moneta Sleet, Jr.: Pulitzer Prize Photojournalist," page 63 of the same Philip Morris document.

— *Corporate Contributions 1988 Year-End Comparative Summary*, Philip Morris Companies Inc., 1989, p. 154A, account of the sums allocated to the Jesse Helms Center.

A spokesperson for Philip Morris thus explained his firm's interest in Jesse Helms's reelection: "Senator Helms has been extremely supportive.... And he is in a position to be of help to us, because of his seniority and his willingness to use parliamentary procedures to his — and our industry's — advantage."

When the New York City Council, in 1994, considered passing restrictions on smoking in public places, Philip Morris asked arts institutions who had received funds from the company to lobby against these restrictions.

The work is based on *Man with a Hat*, 1912, by Pablo Picasso, collection of the Museum of Modern Art, New York. The Picasso collage was on view in the Museum's 1989 exhibition *Picasso and Braque: Pioneering Cubism*, sponsored by Philip Morris.

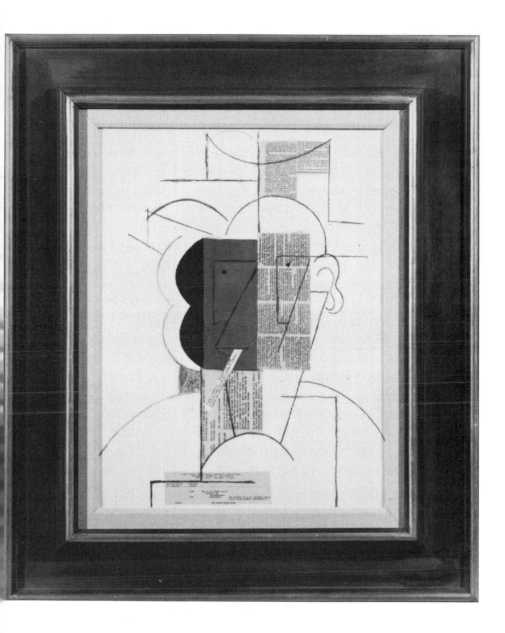

deal of advertising and all political candidates do it, for good reason. Opposed to the sympathizers are, of course, the people who disagree. Some of them disagree to the point of trying to suppress my works — there have been several spectacular examples. The attempts to censor demonstrate, if nothing else, that the censors think an exhibition of my works could have consequences.[34] Between these two extremes exists a sizable audience that is curious and without fixed opinions. It is in this group that one finds people who are prepared to reexamine the provisional positions they hold. Generally speaking, they match the target group of marketing and public relations experts whose job it is to expand the market for a product or for certain opinions. That's also where a good part of the press is situated. (Obviously, this is only a very rough sketch).

Within the group that is primarily interested in what we provisionally called "form" (every time I use this binary terminology which, I think, is absolutely misleading, I get a stomach ache) there is a large contingent of esthetes who maintain that political references contaminate art and introduce what Clement Greenberg called "extra-artistic" elements. For these esthetes, that amounts to nothing but journalism or, worse, to propaganda, comparable to the art of Stalin and the Nazis. Aside from other things, they overlook the fact that my work is far from being appreciated by the powers that be. This "formalist" argument is built on

[34]The director of an American museum told me in 1993 that I could not touch on certain subjects in a one-person exhibition planned by his museum, because he would risk losing his job. I decided not to pursue plans for the exhibition.

the implicit assumption that the objects which constitute (in retrospect) the history of art were produced in a social vacuum, and that they therefore reveal nothing about the environment of their origin. Artists, however, have usually been quite aware of the sociopolitical determinants of their time. In fact, in the past, they often created works designed to serve specific and prescribed goals. Since the nineteenth century, in the West, the situation has become more complex with the disappearance of commissions from the Church and the princes. But already the art of the Dutch bourgeoisie of the seventeenth century demonstrates that it continued to be an expression of ideas, attitudes, and values of the collective social climate or of particular persons of the period. In principle, nothing has changed since. Whether artists like it or not, artworks are always ideological tokens, even if they don't serve identifiable clients by name. As tokens of power and symbolic capital (I hope my use of another one of your terms is correct) they play a political role. Several art movements of this century (among others I am thinking of important factions of the constructivists, the dadaists, and surrealists) quite explicitly pursued political goals. It strikes me that insisting on the "form" or the "message" constitutes a sort of separatism. Both are politically charged. Speaking of the propaganda aspect of all art, I would like to add that the meaning and impact of a given object are not fixed for all eternity. They depend on the context in which one sees them. Fortunately, the majority of people are not particularly concerned about the presumed purity of art. — For obvious reasons, in the art world, people are particu-

larly interested in the *visual* qualities of my works. Questions are raised as to how they relate to the history of art and whether I have developed new approaches. They are more skilled in deciphering the "forms" as signifiers, and there is a greater appreciation of technical aspects. As a counterpart to the people who are able to identify subtle political allusions, my sympathizers in the art world enjoy spotting art-historical references that are inaccessible to a lay audience. I believe that one of the reasons for the recognition my work has gained from a rather diverse public is a sense, shared by the two factions I crudely distinguished (obviously it is more complex), that "form" expresses a "message," and that a "message" would not get through without an appropriate "form." The integration of the two components is what counts.

PB: Do you mean that even when they privilege one of the two aspects, they indistinctly sense the presence of the other?

HH: Yes, I think so.

PB: And that they sense that your works are doubly necessary, from both the point of view of the message and from the point of view of the form and of the relationship between the two?

HH: The context in which the public encounters my works also plays an important role. The people who came upon my installations in the public places of Graz, Munich, and Berlin are different from the museum

public and the still more specialized audience of galleries. People in the latter categories look at my stuff in terms of art, even when they dispute its art status, as Hilton Kramer does. By contrast, the uninitiated passersby in the street see them with different eyes. I often work deliberately for a specific context. The social and political character of the exhibition locale plays a role, as do the architectural peculiarities of the space. In fact, the symbolic qualities of the context are often my most essential materials. A work made for a specific site cannot be moved and exhibited elsewhere. The significance of its physical elements as well depends frequently on the context. For example, the neon Mercedes star which revolves on top of one of the tall buildings one passes on the train when entering Paris from the north means something different from its counterpart on the roof of the Europa Center in Berlin (particularly when the city was still divided by the wall), and from the Mercedes star I planted on a watchtower of the old death strip.

PB: That is also one of the ties that the autonomization of art has broken. The museum effect extracts the work from all contexts, demanding the "pure" gaze. You reestablish the link with the context. What you say takes into consideration the circumstances in which it is said. The proper language is that which is appropriate, opportune, and effective. That's what makes the example of Graz so extraordinary, even in the treatment the public gives the work. It's almost as if you had wanted to lead people to burn the work. Did you foresee that?

Freedom Is Now Simply Going To Be Sponsored — Out of Petty Cash, 1990

Temporary public installation.
Watchtower in former "death strip," neon, Mercedes star, bronze inscriptions; Europa Center (as ready-made), Berlin.
Group exhibition: *The Finiteness of Freedom (Die Endlichkeit der Freiheit)*, Berlin, September 1990.
Photographs by Hans Haacke.

Eleven artists were invited to produce, in the form of a temporary public installation, a work comprised of complementary parts to be undertaken in the two sections of the yet-divided city of Berlin. The effort was financed by the municipality and organized by the Deutscher Akademischer Austauschdienst (along with Wulf Herzogenrath). It opened several months prior to German reunification.

Along the length of its border with West Berlin in 1961, the GDR (East Germany) carved out a zone of empty space delineated by two unscalable walls, electrified fences, land mines, and dog runs. This "border of peace" was under constant surveillance by patrols and from watchtowers equipped with powerful searchlights. In what quickly became known as the "death strip," more than 175 people died attempting to escape to the West.

One of these watchtowers, near the Heinrich-Heine checkpoint, was chosen for this project. Its windows were newly fitted with tinted glass, reminiscent of the Palasthotel in East Berlin, a luxurious residence for the official guests of the GDR. Like the windows of West German police vehicles, they were protected against rock-throwers by wire grills. The rooftop searchlight was replaced by a slowly rotating Mercedes star, enclosed in a wire cage. Particularly at night, the neon star dominated the desolate area of the former death strip. On the roof of the Europa Center, the tallest building in the fashionable shopping district of West Berlin, a matching, though much larger, Mercedes star has been shining for years.

Two inscriptions, in bronze letters, were mounted on opposite sides of the watchtower. They were taken from a series of advertisements in which Daimler-Benz quoted famous people.[1] "Bereit sein ist alles" ("The readiness is all") by Shakespeare (*Hamlet*) echoes "Be prepared — always prepared," the motto of the Young Pioneers, the GDR youth organization. The other quote, "Kunst bleibt Kunst," by Goethe, translated as "Art will always remain art," had also been used in Mercedes ads in the *New York Times*. A few months before the exhibition, Daimler-Benz was in the news when it bought a large piece of empty land at Potsdamer Platz. The site near the former wall was the old center of Berlin and is expected again to become its hub in the future. The municipality sold the tract to Daimler-Benz before an urban plan for the newly opened areas had been developed. The company paid one tenth of the estimated market price.[2] After a complaint was filed with the European authorities in Brussels over unfair public assistance provided to the German corporation, Daimler-Benz was obliged to make additional payments.

Daimler-Benz is among those German industries which had vigorously promoted Hitler's rise to power. Its chairman as well as its chief executive officer were both members of the SS. The majority of German warplanes and military vehicles in World War II were powered by Mercedes engines. Like other companies during the war, Daimler-Benz relied extensively on forced labor. It has since agreed to a compensation of 434 deutsche marks to each of the 48,000 laborers. The firm prospered again after the war, and is presently the largest company in Germany. It is also the largest producer of armaments. It jointly owns, along with the South African government, a factory that has a monopoly of the production of heavy diesel engines in South Africa. During the years of apartheid, the company supplied the South African military and police

with more than 6,000 vehicles, including rocket launchers, in spite of an international arms embargo. The former head of the South African Mercedes subsidiary is now the head of its aerospace division[3] and in line to become chairman of Daimler-Benz.

During the Eighties, Daimler-Benz sold helicopters, military vehicles, and missiles to Iraq,[4] at times in partnership with French firms. It is also suspected of having provided flatbed trucks which served as mobile Scud missile launchers. It has been reported that it is planning to produce cars in Iran,[5] in a joint venture with a foundation of the Revolutionary Guards.

Daimler-Benz is the most conspicuous sponsor of art exhibitions in Germany. It commissioned Andy Warhol to make a series of paintings of its cars from the beginning to the present. They were exhibited posthumously at New York's Guggenheim Museum, sponsored by Mercedes.

[1]Advertisements published, e.g., in *Der Spiegel* and in the *New York Times*.

[2]"Berliner Grundstück zu billig erworben," *Frankfurter Allgemeine Zeitung*, August 15, 1992. "Daimler-Benz will den 'Nachschlag' zunächst nur unter Protest zahlen," *Der Tagesspiegel*, Berlin, April 15, 1992, pp. 1, 2, 13.

[3]"Daimler-Benz during the Nazi era and in South Africa," in *Das Daimler-Benz Buch*, Hamburger Stiftung für Sozialgeschichte des 20. Jahrhunderts (Greno, Nördlingen, 1987).

[4]"Vom Rabatt ein paar Prozent," *Der Spiegel*, 12 (1991) pp. 112–18.

[5]"Rebounding Iranians are Striving for Regional Leadership in Gulf," *New York Times*, November 7, 1992, p. 6.

HH: No, not the firebombing. But we did take precautions. Guards were posted at night. One knows from experience that contemporary sculpture in the public arena, no matter what kind, invites vandalism.

As far as work for a given context is concerned, I would like to add that, as with many questions touching the theory and the sociology of art, there is a precedent in the practice of Marcel Duchamp. When he anonymously entered his *Fountain* in the exhibition of the Society of Independent Artists, he deliberately aimed at a specific context. Being a member of this New York association himself, he knew it well and could imagine what the reaction of his colleagues would be. That's what he played on.

PB: Yes, but, paradoxically, he did somewhat the inverse of what you do. He used the museum as a decontextualizing context, if I may use the expression. That is: I take a urinal and, by the very fact of putting it in a museum, I change its nature, because the museum will have the effect on it that has on all the objects exhibited. It is no longer a triptych or a crucifix before which one will pray, but rather a work of art that one must contemplate.

HH: Today it's a relic. But in 1917 it caused a scandal. Duchamp succeeded in unmasking the unspoken artistic criteria of his colleagues who demanded that this object be excluded from the universe of art. However, when his friend Walter Arensberg purchased the urinal, these criteria were no longer valid. All of a sudden, this urinal was perceived as different from other urinals

96

one could buy in plumbing supply stores in New York, probably for less money. Its meaning had changed. With this maneuver, Duchamp revealed the rules of the game, the symbolic power of the context.

PB: But you minimize the newness of what you do in relation to that. Of course, it is within the same logic. But you reintroduce a context that is no longer just the museum, but rather the village of Graz, the inhabitants of Graz, the Nazis . . .

HH: I believe that most people in the streets of Graz did not respond to my work in terms of art but as a political statement. Consequently, the firebombing was also understood exclusively as a political act. Only people from the world of culture in Graz recognized that it was an assault on art as well. If artists step out of the art context, as I did in Graz (I am not the only one to do this), they operate simultaneously in two different social arenas. Our categories of classification then get scrambled.

I believe the ghettoization of art is a recent phenomenon. Attempts to break out have been made by Tatlin, Heartfield, and others. Rodchenko thought of advertising as a way to fuse art and social action. These efforts are now part of art history. Museums, galleries, and private collections attach symbolic value (and, of course, also economic value) to certain objects, and they provide a refuge, protection, and even a platform to speak from. But for some time now there has been a sense of malaise. I ask myself, however, whether this unease is not based on a romantic notion of the

contemporary world and a profound misunderstanding of the role the assumed ghetto plays in today's practice. The terms "platform" and "ghetto" are contradictory. What interest would corporations have in sponsoring an inaccessible enclave? Why do the neo-conservatives and Senator Helms worry about what happens there? And how are we to explain that vacancies in the directorships of the Pompidou or the Whitney in New York are not viewed like other administrative positions, to be filled by just about any graduate of the ENA or the École du Louvre and its equivalents in the United States?

PB: Can you explain those allusions?

HH: The debate over the directorship of museums goes beyond the complaints about the institutions serving as outlets for art dealers in New York or elsewhere. Explicating the context in which artworks were created, as some do, is branded Marxist, a very damaging label. The most accepted practice remains that of decontextualizing objects, a bit like the presentation of a butterfly collection. It circumvents, by default, the consideration of the social field in which they originated and to which their creators made reference. This is undoubtedly a politically smart practice. But it ends up in a neutralization of art. Art institutions, a bit like schools, are places of education. They influence the way we look at ourselves and how we view our social relations. As is the case in other branches of the consciousness industry, so here, in a subtle way, our values are being negotiated. In fact, art institutions are politi-

cal institutions. One could say that they are part of the battlefield where the conflicting ideological currents of a society clash. The art world, contrary to what is generally assumed, is not a world apart. What happens there is an expression of the world at large and has repercussions outside its confines. Because these relations are not mechanical and the fronts are not clearly drawn, it is not easy to demonstrate this interdependence of art and society. It manifests itself more at the level of the social climate than in specific cases. However, as the meteorological metaphor suggests, what happens in particular geographical regions is not altogether negligible. Climate is a soft concept. However, I am convinced that is where the general direction of societies are, almost imperceptibly, decided.

PB: That being said, according to the forms of art, the rift is more or less great. Nevertheless, there are forms of art that institute and live from this rift.

HH: But these forms influence what I call the climate, too.

PB: Yes, at least negatively. By not doing what they could do . . .

HH: At the beginning of the 1980s, a dozen years after the cultural revolution of the 1960s, there was a boom in neo-expressionist painting. The domination of the scene by this expressionism and a revival of the traditions of painting were the signal for the end of a rich period of experimentation, analysis, and social

engagement. Following this trend, Documenta 1982 more or less certified the restoration of a mythic world: the individual as independent agent, the artist as demigod, challenger of the world, in short: Rambo.[35] This coincided, in the United States, with the arrival of Reagan in the White House and in Bonn, a bit later, of Kohl in the Chancellery. Margaret Thatcher was already busy dismantling the welfare state (and her country) for the sake of "free enterprise." Her American friend prepared a defense against the "Evil Empire" for the upcoming Star Wars. Charles Saatchi, chief of the advertising agency that ran Maggie's election campaigns, bought the new paintings wholesale and made their prices soar. Of course, out of public view, work that was not "in" continued underground, and there were young artists who developed new ways which were to be recognized much later. It would be unfair to accuse the artists (and their following) who made a fortune under these circumstances of having consciously promoted the policies of the people in power. However, I believe that, at the level of the climate, there was a mutually profitable collaboration.

[35] Ten years later, Jan Hoet, the director of Documenta in 1992, openly excluded works which made explicit political allusions. Instead, he opted for what he called "mystery" (interview with Hans-Joachim Müller, *Die Zeit*).

PB: It remains to be asked what an action inspired by the symbolic strategies that you have set in motion might be. Can we say that mobilization is possible, and particularly on an international scale, based on a sort of elevation of the collective consciousness, such as that which occurred following the cases of censorship in the United States? There are large cities where both economic and symbolic power are concentrated, sites of symbolic consecration which are often sites of economic power, such as in Germany and the United States. Struggles exist within each nation to try to develop counter-powers against the concentration of publishers, against the concentration of important galleries, or against the power of museum directors. But there are also truly international forms of domination, of the North over the South, for example. You participated in the international exhibition which posed this question to a certain extent, in Paris . . .

HH: *The Magicians of the Earth.* The exhibition tried to present artists from the Third World on an equal footing with Western artists. Generally speaking, the show was not well received. On one side were those who complained that this was just another form of colonialism, while critics on the other side made fun of the "kitsch" of the "exotics." In spite of many obvious problems, I think it was a very significant and courageous project. I learned a lot. A Haitian sculptor whom I met at the photocopying machine of the Beau-

One Day the Lions of Dulcie September Will Spout Water in Jubilation, 1988/89

Installation.
Exhibition: *Magicians of the Earth* (*Les Magiciens de la terre*), Centre Georges Pompidou and Parc de la Villette, Paris, 1989.
Curator: Jean-Hubert Martin.
Photo of flag by Pete Schuit.

The colors of the African National Congress (ANC) form the upper part of the flag. Black represents the black nation, green the land, gold the natural resources of South Africa. The lower part of the flag, tied in a knot, has the colors of the flag of the Republic of South Africa. For *Magicians of the Earth*, the flag *"Apartheid"* was raised above a Napoleonic fountain in front of the exhibition hall at Parc de la Villette. The large, lower basin of the fountain was filled with black water, the lions were gilded, and the shaft of the fountain, with its upper basins in the shape of a palm tree, were painted green.

Dulcie September was the ANC representative in France. She was assassinated in Paris in 1988.

bourg, and who visited me later in New York, confirmed that for him and his colleagues this was a very important event. He was rightfully furious about the arrogance of people who dismissed interest in his work as exoticism.

PB: Europe and America's domination of the world of painting is absolutely overwhelming. In literature it is less visible, but, in fact, it is almost the same thing, and instances of legitimacy are also found in the United States, in France, in England, etc. There is an extraordinary concentration of the power of consecration. Are actions on a national scale sufficiently effective, or might it not be necessary to conceive of actions on an international scale insofar as many mechanisms of domination are transnational? Right-wing intellectual movements are organized internationally, in part because they were born from the fear of subversive student movements. By contrast, the others work in a dispersed manner.

HH: I am not sure whether things are so desperate. There is a global network of communication — there are journals and personal exchanges. Your books, for example, are widely translated and read. Recently they inspired a group of young artists in Germany and the United States. In spite of everything, I manage to exhibit internationally. But it is true that the conservatives have greater resources by far. They are better organized, they are perhaps more successful at reconciling internal differences — and they are in power. We should also recognize that they use a language which

has the air of the "normal." What we probably lack is a sense for the practical. Too often we are stuck in a world of theoretical speculation without sufficient grounding in real life. That can lead to paralysis when action is called for. We have the unfortunate example of the intellectual rebels in East Germany: once the oppressive regime was swept away, they withdrew to discussion groups rather than energetically filling the political vacuum that existed for a brief moment. To get back to the question of language, too often the intellectual journals of the Left use an esoteric language. Even if it is not the intention of the users, this language serves only initiates, people of "distinction." It perpetuates their isolation. It would be better to develop strategies and a language capable of inserting their ideas into the general public discourse.

PB: The esthetic language you use remains rather esoteric, in fact ... One must be well informed about the history of art to understand its logic ... That is one of the contradictions. It's the same thing in the social sciences. People tell me all the time: that's all well and good, but the people your sociology could help do not read it; and those who read it often use it only to further what you would want to hinder. That is a deep contradiction. We cannot at the same time use languages that suppose years and years of accumulation (the language you use presupposes the entire history of art, at least since Duchamp ...) and be accessible to the first passerby, even if the message is ...

HH: It's true, there are some esoteric works. These

are the pieces which are meant to address my peers. They are part of an internal professional debate. They do, however, reflect positions held outside this circle of insiders. *Baudrichard's Ecstasy* is a good example. The work was made for a New York gallery in Soho which counts connoisseurs of Duchamp and Baudrillard among its clientele. I believe, though, that works like *Helmsboro Country* which I produced for a more heterogeneous audience, and those I designed for public places and museum exhibitions are comprehensible for nonspecialists. Sometimes I am mistaken. My piece for the *Magicians of the Earth* is an example. Contrary to my expectations, nobody knew the flag of the ANC or, for that matter, the flag of South Africa. If the banner of Nelson Mandela's liberation movement had been recognized as freely flying above the knotted flag of the apartheid state in one of the most prominent spots of the exhibition (the *Lions Fountain* in front of the Great Hall of la Villette), it could have become a public issue.

PB: I think that one of the solutions to the problem of the break with the public could be to produce messages on several levels, like the poets in the oral traditions. They had a discourse that could be understood by everyone, but which could also be the object of esoteric interpretations understood by only a few. That's somewhat like what we have tried to do in our journal *Actes de la recherche en sciences sociales* by trying to express an analysis (that of high fashion, for example) in two ways: through photographs (organized according to a certain structure) and through the ana-

lytical text. I believe that can be done in a very general way. But that is a special kind of research, for which intellectuals are not prepared. Besides, they finally admitted that the break between research and the general public was inevitable. That is another merit of what you do . . . You do not accept being condemned to esotericism as a *fait accompli.*

HH: If one pays attention to the forms and the language that are accessible to an uninitiated public, one can discover things that could enrich the esoteric repertoire.

PB: Therefore, contrary to what is said, the intention of reaching a broad public, far from leading *in all cases* to concessions of esthetic compromises, to lowering the level, may well be a source of esthetic discoveries.

HH: One can learn a lot from advertising. Among the mercenaries of the advertising world are very smart people, real experts in communication. It makes practical sense to learn techniques and strategies of communication. Without knowing them, it is impossible to subvert them.

PB: To undertake forms of action which are at the same time symbolically effective and politically complex and rigorous, without concessions, wouldn't it be necessary to form teams composed of researchers, artists, theater people, communication specialists (publicists, graphic artists, journalists, etc.) and thus

mobilize a force equivalent to the symbolic forces that must be confronted?

HH: I believe it is very important that it be fun. It has to be enjoyable. It must be a pleasure for the public to get involved. Bertolt Brecht said it well.

PB: Yes, but you are giving the definition of your métier . . . With esthetics you are on the side of feeling, sensitivity, and pleasure. That is also true of writers. But can and should philosophers, sociologists, everyone who is on the side of the concept, of the intelligible, propose giving pleasure? The truth is that if they do so, people think that they are after cost-free success. And it must be said, those who give pleasure often chase after success.

HH: I don't believe the work of a philosopher or a scientist cannot be pleasurable. There are texts I enjoy reading, and there are others I detest because of their bureaucratic and pretentious language. I don't finish reading them, even if the subject interests me.

PB: I think your work represents a kind of avant-garde of that which could be the action of intellectuals. It could serve as a critical analyzer of the moment of transmission of knowledge in relation to the moment of the conception and of the research itself. Everything makes me think that intellectuals are not at all concerned about the moment of the *performance*, and that they do not make it an object of research. And it is to a large extent for this reason that they are so little

effective. I think they should take inspiration from research like yours or that of Andrea Fraser in order to give full symbolic effectiveness to their unveiling of social mechanisms, particularly of those who rule the world of culture.

HH: Does it surprise you when I tell you that your writing is effective? Through the "game" of writing, you succeed in communicating clearly your scientific discoveries, sometimes even in a conversational tone. Moving from the abstract to the more concrete, you put your finger on some of the most complex social realities. That is a great public service. You have taught me a lot, and I enjoyed learning it. As you say, if the intellectual professions seek to reach a larger public and to create a class of sophisticated people (including the press) who are able to play a constructive role in the negotiations of the "social contract," it has to be fun to get involved. If it's annoying, they go somewhere else — and they will be paid more. One of the biggies of French advertising proposed that modern marketing strategies must appeal to people's sophistication. The lesson I draw from this is that there exists a "target group" who takes pleasure in being taken seriously. We should not abandon them to advertising.

PB: People spontaneously think that being serious or profound is being boring or unattractive. I think that an analysis of unconscious views of intellectual work could liberate the energy of pleasure and, at the same time, symbolic energy. It may be that what we are in

the process of doing will contribute a little to producing that effect . . .

One of the principles of your strategy consists in using the strength of the adversary, somewhat like combat sports such as judo: they use the press, and you use the press to make your use of the press known. By the logic of your work, you have been led to develop a strategic reflection that is included in your work, whereas intellectuals often associate their identity and their intellectual dignity with the fact that they are not concerned with such things.

Besides, they do not really believe that they could be effective. And, suddenly, they do not even ask themselves the question of the conditions of effectiveness, of strategies of communication, etc. This is what makes you a kind of analyzer who opens possibilities: what you do brings to light that which others do not do, but could do.

HH: Of course, there are constraints. But the game is never completely fixed. Even in exile, during the Nazi regime, Bertolt Brecht asked himself how one could tell the truth in Germany. In his 1935 essay about the "Five Difficulties in Writing the Truth" he offered a list of what it takes to write the truth: the courage to write it, the intelligence to recognize it, the art to use it as a weapon, the practical sense for the choice of those who could make use of it most effectively, and the cunning to spread it widely. Fortunately, we don't work today under the constraints of a Fascist regime. Let me return to the example of Munich to illustrate my point about why, for various reasons, the game

remains open. In terms of culture, Munich has the reputation of being a bit behind the times. Everybody agrees that it is very pleasant to live in Munich: there are the beer gardens in the summer, one can go skiing in the mountains nearby. But the cultural events that matter take place elsewhere, particularly in the visual arts. The city's chiefs began to ask themselves whether this deficiency could eventually have negative consequences for their ability to attract sophisticated people for managerial vacancies and to keep these people's minds nimble, a precondition for the vitality of the city's economy. They decided, as have other cities, to create high-visibility cultural events. The exhibition on Königsplatz was part of this strategy. The context offered by the curator (Werner Fenz from Graz was invited by the city to organize the show) was such that it could be used without risk that one's work becomes mindless entertainment. Undoubtedly it was helpful for us that Munich is governed by Social Democrats. By contrast, the government of the State of Bavaria is very conservative. It would never have agreed to an exhibition concept which demanded that the participating artists make reference to the Hitler past of Bavaria.

PB: You constantly divert forces and forms . . .

HH: The Left is often afraid that its ideas are co-opted. This fear sometimes reaches such a level of paranoia that all action stops. Naturally, one has to examine things case by case. But the most profound effect in the end is total co-optation. I will give you an example. In Germany, perhaps also in France and in

other countries, concern for the environment was originally an issue of the Left. After more than a dozen years, it is now sufficiently accepted by the general population that Mercedes and other companies use ecological themes in their advertising campaigns. This is co-optation, but it is also a powerful boost for ecology.

PB: In French, there is a beautiful expression: we speak of "white lies" [*mensonge pieux*]. And we also say that "hypocrisy is a tribute that vice renders to virtue." ... The fact that Mercedes is forced to pay tribute to ecology is, no matter what one says, a step in the right direction ...

HH: It gives politicians courage. If it's accepted even by Mercedes, laws can be passed.

PB: That perhaps, is, realism, the *Realpolitik* of reason ...

Pierre Bourdieu

Too Good to be True

> That's fine, isn't it? It has a prophetic vision. *Fuit
> Ilium!* The sack of windy Troy. Kingdoms of this world.
> The masters of the Mediterranean are the fellaheen
> today.
>
> James Joyce, *Ulysses*

It's too good to be true. It must be a dream. The catalog
of the forty-fifth international art exhibition in Venice
opens with a prologue by Ernst Jünger in which the
old esthete, disillusioned, except of course in relation
to his indulgences of Nazism and anti-Semitism, pours
out his politico-metaphysical bric-à–brac worthy of the
most beautiful days of the 1930s: mythical figures of
old, gods and Titans, obligatory references of the revol-
utionary conservative cult, Nietzsche and Heidegger,
Tolstoy and Hölderlin, Schopenhauer and Spengler, the
twilight of the gods and the sinking of the Titanic,
but also critical divisions: Cuvier's creationism versus
Darwin's evolutionism, the atemporality of preindus-
trial symbols (and of the Nation, with its tradition and

113

its "landscapes") versus the time of technique — whose innovations provoke wars and migrations. This esthetic of politics which readily pours forth into the esotericism of a pretended magic realism, devoted to grasping the profound reality of the national mystique under the flimsy appearances of the moment, is naturally fulfilled in a politicization of the esthetic: the cult of the work of art is the result of the formal mutation (*Gestaltwandel*) which, at the end of a change in appearance through which the gods are venerated, led to the institution of new sacred places. Like the ancient temples whose place they have taken, the cult's holy places are the destination of pilgrimages, with occasions for festivities, offerings, and contemplation. No one could say it better, and M. Achille Bonito Oliva must be happy!

If Jünger didn't exist, Hans Haacke no doubt would have invented him ... What is more extraordinary in effect, and at the same time more necessary, than this total meeting (putting body and life into play, according to Jünger's definition) between the past that the militarist cantor of a revolutionary nationalism evokes, as if in spite of himself, and that which the critical artist makes reemerge in its exemplary actuality.

By giving in to the compulsive repetition of the most well-worn themes of the ordinary thematics of elitism with heroic pretensions in which a certain cult of art is quite naturally inscribed, the author of *Der Arbeiter* (*The Worker*, a text dear to Heidegger, who is twice evoked in the catalog's preface) recalls, to those who

know how to read,[1] not just the past and nothing more, like all today's celebrators, but rather the actual presence of the past in the living present.

In so doing, Jünger quite precisely comes upon the intention of Hans Haacke, who transforms the recreation of the memory of the past into a critical questioning of the present by making a few minimal but decisive modifications in the old setting. On the one hand, taking advantage of photography's ultra-realist evocative capacity, Hans Haacke installs, at the entrance to the stand where he was invited to exhibit — and which, constructed in the 1930s, had been left in its original condition — the life-size photography of Hitler's visit to the Biennial in 1934, reestablishing the site of the exhibition, which is thus constituted as an object of exhibition in its original meaning and function. On the other hand, always with the same economy of means that contributes so much to artistic effectiveness, he replaces the imperial eagle that crowned the entryway with an enlarged reproduction of the sovereign deutschmark, whose law extends to the world of art. He thus recalls the hegemony of the great reunified nation that Hitler also came to affirm (the very same Hitler who, if we believe the priceless Jünger, would have only his character to blame for his now forgotten ultimate defeat . . .).

This liberating evocation frees the present which is

[1]They are, without doubt, quite rare, like those who are surprised by all the honors the highest (socialist) authorities of the French Republic have bestowed on Ernst Jünger and of which Lionel Richard recently established the list ("Un timbre à l'effigie de Jünger" . . . *Le Jour*, no. 58 (June 5–6, 1993).

enclosed in the past, and which simple commemoration leaves untouched. It forces us to confront everything that the past, apparently dead and buried, has to say about the present; also everything that is at times proclaimed, as long as one knows how to listen, in the current remarks and acts of those who, at the price of some opportunistic *Gestaltwandel* (the Jews or Israel, henceforth censured, giving way to the *fellaheen* or to Islam, delivered in a strange lapse), can indefinitely repeat, and with the same success amongst the faithful, the tired litanies of the devotion that the (Western) elite has never ceased rendering to itself, notably through the cult of the artist and the work of art.

Germania, 1993

Installation in the pavilion of the FRG, at the
Biennale of Venice, 1993.
Wood partition, eight letters; facsimile of a
1990 deutsche mark coin; photo of Hitler at
the Biennale of Venice in 1934 (Source: Archi-
vio storico delle arti contemporanee, La Bien-
nale di Venezia); 1,000–watt projector.
Curator: Klaus Bussmann.
Technical direction: Florian Matzner.
Photographs by Roman Mensing.

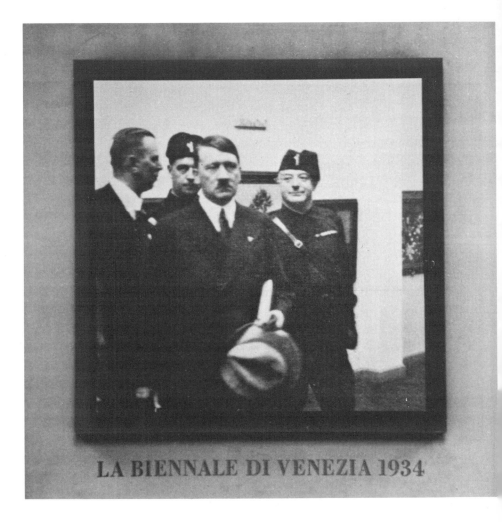

LA BIENNALE DI VENEZIA 1934

Hans Haacke
Gondola! Gondola!

"Gondola! Gondola! That is the battle cry of Venice."
With this opening line the party paper of the capital of
the Reich opened its first-page atmospheric report from
Venice, on June 14, 1934.[1] The following day, the corres-
pondent cabled enthusiastically: "The gondolas, mar-
velously festooned with lanterns, come to a stop at the
Biennale. Aristocratic ladies alight, men stride
solemnly . . . Has there really ever been a time in Ger-
many when the Führer was called a foreigner? Venice
greets him with the *Meistersinger*! He sits to the right
of the Duce."[2]

What is behind this story? An Austrian postcard
painter was on his first trip to Italy. He had a friend
down there, Benito. A dozen years ago, Benito had
made a march on Rome and taken over the place. That
inspired the postcard painter to try something similar
a year later in Munich. It was a flop. It took him until
1933 to pull off a coup in Berlin. Thus, a celebration
was in order. But Adolfo, as the Italians called him, was
very busy at first. They had to wait for an entire year.

[1] Gustav W. Eberlein, "Venedig feiert Hitler," *Berliner Lokal-Anzeiger*,
Zentralorgan für die Reichshauptstadt, 278 (June 15, 1934), p. 1.

[2] *Idem*, "Venedigs grosse Tage," *Berliner Lokal-Anzeiger*, 279 (June 16,
1934), p. 1.

Only then could the two friends go on a vacation together in Venice. Benito threw him a tremendous welcoming party, with everything Venice had to offer. After the first night, again there was plenty going on. Already at the crack of dawn, there was shouting in the Piazza San Marco: "Evviva Hitler!" Berliners read in the paper on the following day: "Throngs of Fascist maidens in black skirts and white blouses were on their feet."[3] But not only girls were filling the streets. Blackshirts, too, were lining up *en masse*: "The avant-gardists left a particularly good impression. The human material was excellent."[4] Benito appeared in full regalia on the grandstand that had been put up in front of the Caffè Florian. "There was a reveling in light and colors, costumes and beauty. And as always, there was the blue sky of the South."[5] The press spoke of a "frenzy of enthusiasm."

After the celebration of the Piazza San Marco, the postcard painter took a motorboat to the Biennale. As a former denizen of Schwabing, he was curious to see what his colleagues had been up to. At the Giardini Pubblici landing, he was greeted by Count Giuseppe Volpi di Misurata,[6] the president of the Biennale, and

[3] Ibid.

[4] "Der Vorbeimarsch der Giovani Fascisti," Ibid.

[5] "Faschistenparade vor Hitler," Ibid.

[6] Sergio Romano, *Giuseppe Volpi et l'Italie moderne: Finance, industrie et l'État de l'ère giolittienne à la Deuxième Guerre mondiale*, trans. Sophie Gherardi, (1979; repr. Rome: École Française de Rome, 1982; Rolf Petri, "Industriestadt im Zugriff des grossen Geldes," in *Venedig: Ein politisches Reisebuch*, ed. Rolf Petri (VSA Verlag, Hamburg, 1986), pp. 113–17; Maurizio Reberschak, "Faschismus, Antifaschismus, Widerstand," in ibid., pp. 118–31; Mario Isneghi, "Die Biennale: Väter und Söhne," ibid., pp. 195–211; Rolf Petri, "Disneyland in der Lagune: Tourismus als Selbstentfremdung," in ibid., pp. 213–21.

by Antonio Maraini, its general secretary. Like the 2,000 *giovani fascisti* who had lined up to welcome him, the two gentlemen had donned the local black garb with boots, shoulder strap, and decorations that had become fashionable in those years. This black costume was only one of many in which the goateed Count Volpi moved in the circles of international finance and politics. He had busied himself, among other places, on the Balkans, at Rapallo, in regional electric power companies, banking, insurance, and in transportation. As a *condottiere* and governor of the Italian colony of Tripolitania, he had won the title of Count as well as large land holdings. Together with Vittorio Cini and Achille Gaggia, Volpi had been promoting a new port and industrial zone at Marghera, near Mestre on the mainland. To venerable Venice they had assigned the role of a museum island with fully integrated service industries. Volpi, the godfather of Venice, had substantial interests on both sides of the lagoon. Benito's guest from Berlin, for example, was lodged in the Grand Hotel, which was one of many luxury hotels belonging to his CIGA chain. The agile tactician had been an early patron of the Venetian *fascio* — perhaps assuming that his revolutionary political friends would protect him from the red menace. When things had reliably settled in 1922, he joined the party. The Duce thought highly of him. In 1925 he entrusted the Venetian senator with his ministry of finance, and a few months after the Biennale visit from Berlin, he made him president of the Italian Association of Industrialists. As head of CONFINDUSTRIA, he had frequent dealings with the newly established Reichsgruppe Industrie. Like his col-

league Hermann Josef Abs of the Deutsche Bank in the cold North, the busy Count of Misurati warmed seats in more than forty different boardrooms.[7]

After the big crash, both men were able to rely on old business friends abroad. Happily, their exoneration was assured (for the comrade-in-arms up north this turned out to be the prelude to a spectacular postwar career and, in his old age, even the occupation of the Städel Museum in Frankfurt. Only in the United States is he still *persona non grata*). No question, Benito's Biennale guest was not received by some doddering impoverished nobleman, who had charitably been put in charge of an honorary culture post: Il Conte Giuseppe Volpi di Misurata was a seasoned man, well versed in all the dirty tricks Venice had in store.

The painter from Schwabing made his way immediately to the German pavilion. In 1934 it had been decorated by Eberhard Hanfstaengl, who had just been appointed director of the National Gallery in Berlin (he was a cousin of his good friend Putzi from Munich). For a good while he stayed silently in the first room, contemplating the bust of Hindenburg. Then he saw himself confronted with Ferdinand Liebermann's *Reich Chancellor Hitler*. He looked deeply into his bronze eyes. What he found there has not been recorded. Eventually, without comment, he turned away. Joseph

[7] Hans Haacke, "Manet-PROJEKT '74." First exhibited at Galerie Paul Maenz, Cologne, 1974. Facsimile reproduction in Hans Haacke, *Framing and Being Framed* (The Press of the Nova Scotia College of Art and Design and New York University Press, Halifax and New York, 1975), pp. 69–94. Also in *Hans Haacke: Unfinished Business*, ed. Brian Wallis (The New Museum of Contemporary Art and M.I.T. Press, New York and Cambridge, 1986) and other exhibition catalogues.

Wackerle's *National Emblem*, an excellent example for his new corporate identity program, filled him with new confidence in predestination. Continuing on his tour, he had occasion to celebrate a happy reunion with the *German Soil*, a painting by Werner Peine from his own collection. In the intoxicating atmosphere of Venice, this painting offered a welcome opportunity to reconnect with the heaviness of the earth at home and with the discipline of the German peasant.[8] Finally, facing Georg Kolbe's *Statue for a Stadium*, a giant nudist, he was inspired to think about film projects for Leni Ricfcnstahl. Not only was he a lover of the visual arts and architecture, for many years he had also been a movie buff. Like so much else, he shared this passion with his *cicerone*. The Biennale president, in fact, was the one who in 1932 had instigated the Venice Film Festival — even though he was also occupying the office of provost of San Marco. Naturally, like the Biennale, the Festival played an important part in his investments in the local tourist industry. Volpi had also acted as patron saint at times, when trouble was brewing in Rome over some hot scenes on the silver screen. At the end of his tour, our vacationer was clearly pleased.

The *Reichskulturkammer* of his Ministry of Public Relations under Joseph Goebbels had done an excel-

[8] Annette Lagler, *Biennale Venedig: Der deutsche Beitrag und seine Theorie in der Chronologie von Zusammenkunft und Abgrenzung*, (diss., Technische Hochschule, Aachen, 1991), pp. 169–79; "La visita di Hitler alla XIX Biennale, *Gazzetta di Venezia* (June 16, 1934), Venice, pp. 10–11; "Hitler alla Biennale," *Tevere* (June 16,, 1934), Rome; "La visita di Hitler alla Biennale," *Gazzetta del Popolo* (June 16, 1934), Turin; "Besuch der Kunstausstellung 'Biennale,"' *Völkischer Beobachter*, 167 (June 16, 1934), Berlin, p.1.

lent job. To be sure, there were a few minor glitches, such as the exhibition of Kolbe's bust of Hans Prinzhorn and Barlach's *Monks Reading*. That had to do with an argument that was still raging between Goebbels, who was known for his connoisseurship, and the hard line of the national observer Alfred Rosenberg. They quarreled over whether the expressionists were to be branded cultural Bolsheviks or whether their angular style was, in fact, a perfect representation of the new era (Goebbels, the consummate PR man, had a penchant for modern art. During the preceding year, he had sponsored a futurist show in Berlin, and prior to Fritz Lang's sudden departure from *Metropolis*, he had seriously considered entrusting him with the supervision of the entire film production of the Reich). For the time being, in Venice, the Biennale visitor let his hosts know how much he appreciated their efforts. During their warm farewell, Antonio Maraini, the General Secretary, expressed the hope that the German pavilion would be enlarged in the near future and equipped with state-of-the-art exhibition technology. Within a few years, this wish was to be fulfilled. In spite of the inclusion of Prinzhorn and Barlach, Eberhard Hanfstaengl had done his *Kulturarbeit* with such loyalty that he was allowed to continue in 1936 (his triumphal period, however, had to wait until 1948; for ten years, until 1958, the buddy from Munich atoned).

No doubt, the *Kraft durch Freude* [Strength through Joy] excursion to Venice could be chalked up as a fantastic success. The enthusiastic review in the *Lavoro Fascista* served as a confirmation: "The fact that Fascism and National Socialism let the seeds of a new

130

culture sprout is the best guarantee for the peaceful intentions of Fascist Italy and National Socialist Germany."[9]

This editorial from Rome was both high praise and an appeal to diligently nurture the frail shoots of the new German will to culture. It was a matter of defending German soil and German blood against all that was foreign. Martin Heidegger, as president of the University of Freiburg, had already announced in 1933, in a proud *Declaration of allegiance to Adolf Hitler and the National Socialist State*: "We have completely broken with idolizing a thinking without bottom and without power."[10] Contemplating human existence, the New Age philosopher arrived at the conclusion: "Superman belongs to that race [Schlag] of mankind which, above all, wills itself as race, and allies itself with that race . . . Amidst the meaningless whole, this race [*Menschenschlag*], posits the will to power as the 'meaning of the earth'. The final stage of European nihilism is 'catastrophy' in the sense of an affirmative turnabout."[11] Superman's race struck. Marxist, Jewish, and democratic literature was purged by fire (born late, Hans Jürgen Syberberg recently joined in the opinion that the Left and the Jews were responsible for the misery of German culture).[12] The cleansing had begun.

[9] "Aus der italienischen Presse," *Frankfurter Zeitung* (June 16, 1934), Frankfurt, p. 1.

[10] Martin Heidegger, cited in Jürgen Habermas, *Der philosophische Diskurs der Moderne* (Suhrkamp, Frankfurt, 1985), p. 187.

[11] Martin Heidegger, *Nietzsche* (Pfullingen, 1961), vol. 2, p. 313; cited in Habermas, *Dephilosophische Diskurs der Moderne*, p. 159.

[12] Hans Jürgen Syberberg, *Vom Unglück und Glück der Kunst in Deutschland nach dem letzten Kriege* (Matthes & Seitz, Munich, 1990).

The 1936 Olympic Games in Berlin offered another opportunity to spread the image of the New German around the world. *Mens sana in corpore sano sit.* Shortly after his return from the sun of Italy, the tanned vacationer laid down the ardently awaited line in the quarrel over pictures: "Our resolve was firm that the driveling Dadaist-Cubist and Futuristic 'experience'- and 'objectivity'-mongers would never, under any circumstances, be allowed any part in our cultural rebirth."[13] Tried and tested artists like Joseph Wackerle and Arno Breker, as well as Leni Riefenstahl, were given major commissions. The Bauhaus artist Herbert Bayer also came on board. He produced a brash design for the *Deutschland Ausstellung 1936* exhibition guide (six years later he took care of *The Road to Victory* at the Museum of Modern Art in New York).[14] For artists who did not belong to the *Field and Stream* variety but thought their works were nevertheless compatible with the dominant *Zeitgeist* — many well-known modern artists held such mistaken beliefs — the year 1937 turned out to be a major educational experience. In Munich, the chief artist of the Reich inaugurated his Haus der Deutschen Kunst with a representative selection from the pool of new creativity — and they were not invited. Instead, their products could be inspected in the *Degenerate Art* exhibition around the corner.

[13] Adolf Hitler, Speech at Reichsparteitag, 1935, cited in *Degenerate Art: The Fate of the Avant-garde in Nazi Germany*, ed Stephie Barron, Los Angeles County Museum of Art, 1991), p. 386.

[14] Herbert Bayer, "Inszenierung der Macht: Herbert Bayer, Kataloggestaltung," in *Inszenierung der Macht: Ästhetische Faszination im Faschismus*, ed. Klaus Behnken, Frank Wagner (NGBK, Berlin, 1978), pp. 286–97; Benjamin H. D. Buchloh, "From Factura to Factography," October, 30 (fall 1984), pp. 80–119.

The year 1937 was also when preparations for the next Biennale got under way. The new *völkisch* art was to be presented to the world in a monumental new building, representative of the power and self-confidence of the Third Reich, not in that classicist treasure box in which Count Volpi's guest had encountered his double in 1934. Like the old building, the new one was to be designed by a Bavarian architect.[15] Professor Ernst Haiger from Munich, the *Stadt der Bewegung* [City of the Movement], got the commission. In January of 1938 the professor informed the general secretary of the Biennale that the Führer had approved his plans (this decision was not surprising, since he had faithfully followed the model of Paul Ludwig Troost, the ocean-liner decorator). He closed his letter with a remark which beautifully linked economic and political considerations with esthetic expectations: "Since the costs of the construction will be covered by the German government, I am looking forward to a concession on your part in regard to the reshaping of the area in front of the building. It needs more symmetry."[16] In response, Commendatore Bazzoni asserted his proprietory rights. He agreed, however, to meet the Axis partner half way. One of the three trees which was in the way was cut down, and the Società Anonima Cementi Armati of Venice streamlined the pavilion à la Munich in the record time of 64 days. The master architect described his work in a statement: "Tall and strong pillars of

[15] Lagler, *Biennale Venedig*, pp. 118f., 179f.

[16] Letter of Ernst Haiger to Commendatore Bazzoni, general secretary of the Biennale, January 10, 1938; Archivio storico delle arti contemporanee, La Biennale di Venezia, Venice.

stone carry the portico, above the entrance the national emblem of the Third Reich prepares us for the new spirit of German art."[17] A stone mason of the Società Anonima chiseled, in unadorned simple letters, the word GERMANIA into the entablature. The Bavarian drawing-room parquet of the old pavilion was replaced by Chiampo mandorlato, a stone similar to Istrian marble, in order to lend the interior a cool and solemn appearance. On November 2, 1938, the periodical of the Building Department of the Prussian Ministry of Finance gave the edifice an excellent review: "It is not immaterial in what setting the art of our German fatherland is presented abroad. The new German exhibition hall in Venice is not only an impressive and distinguished representation of the Third Reich, it also demonstrates that an artistically perfect environment will enhance the art works it houses."[18] A week after this review, the Jews of the Reich were given a crystal shower.

"The Master of the Pubic Hair" was granted first crack in the new state chapel in Venice. Adolf Ziegler had well earned it as master of the Haus der Deutschen Kunst in Munich. Now in the Giardini Pubblici, he proved his manhood again. His exhibition concept assigned the central role to the boss's two favorite artists.[19] In their work he recognized "The forceful

[17] Ernst Haiger. "Der neue deutsche Ausstellungsbau der Biennale in Venedig," April 19, 1938 (typewritten); Archivio storico delle arti contemporanee, La Biennale di Venezia, Venice.

[18] G., "Das deutsche Kunstausstellungsgebäude in Venedig," *Zentralblatt der Bauverwaltung, vereinigt mit Zeitschrift für Bauwesen,* Ed. Prussian Ministry of Finance, Berlin 58 (November 2, 1938). 44, pp. 1192–5.

[19] Lagler, A., *Biennale Venedig,* pp. 182–8.

spirit of our people's race and the manifestations of a proud past have once more revealed the German soul."[20] Coyly waving a laurel twig, Arno Breker's *Heroine* and her *Decathlete* companion did an impressive burlesque number as nude sentries (they had trained together at the 1936 Berlin Olympics). By comparison, Thorak's *tête-à-tête* of *Führer* and *Duce* were rather chaste. Breker's ensemble, in fact, amounted to an exquisite foreplay for the next date in Venice. In 1940, the first year of the war, Breker's bodybuilder demonstrated his *Readiness*. Already from the steps leading up to the portico, the pilgrim could see through the open door, far away in the depth of the apse, the resplendent hunk drawing his sword, his eyes firmly turned towards the East (the master had put the last touches on the magnificent body before the invasion of Poland). It was a peak performance. The creator was awarded the Grand Prix.

After this high point in Venice, Arno Breker distinguished himself with great bravery on the homefront. With blind devotion to his supreme commander, he fought in his studio to the last drop of blood. He was on special assignment. Meanwhile, smoke signals appeared in the sky like those rising from incinerators. Venice was included in the general cleansing. And as far as one could see, the fields of honor were being fertilized. When the time clocks of the Thousand-Year Reich refused service after twelve years and Breker's patron of many years went down ingloriously, there was only a brief pause for the tenacious fighter. Old

[20] Adolf Ziegler, Catalogue *XXI Biennale di Venezia*, (1938), p. 257.

comrades such as Maillol, Vlaminck, Céline, Cocteau and Jean Marais, Salvador Dali, Ezra Pound, and, of course, Winifred Wagner and Ernst Jünger needed busts. However, new admirers from trade and industry knocked on the door of his studio in Düsseldorf, too. There were even commissions from statesmen for the creator of the *Party* and the *Armed Forces*, two monumental action figures that had been guarding the entrance to the Reich Chancellery in Berlin until the end. Among the new clients were the Christian Democrats Konrad Adenauer and Ludwig Erhard. The easygoing father of the German miracle sent the yapping pip-squeaks packing: "The rebuilding of a country requires not only economic efforts from a people, but also reflection on its spiritual and cultural values. Arno Breker's artistic achievements have survived all kinds of political favors and resentments because of their unshakable foundation. An artist like Breker, tolerant and unwavering, who works with a deep commitment to Christian ethics and the Good, needs no defense. Through his work Breker defends man's freedom and dignity in society."[21]

Unfortunately, the man who had made the deutsche mark roll lacked the art-world reputation necessary to shield the master from petulant grumbling. Art connoisseurs with impeccable credentials had to come forward. Peter Ludwig and Baron Hans Heinrich Thyssen-Bornemisza stepped in. As a sign of their

[21] Ludwig Erhard, 1974, cited from *Form und Schönheit* (Publ. Salzburger Kulturvereinigung, 1978), p. 15; in Siegfried Salzmann, *"Der Fall Breker."* *Im Namen des Volkes: Das 'gesunde Volksempfinden' als Kunstmassstab* Wilhelm-Lehmbruck-Museum, Duisburg, 1979, p. 160.

admiration, they commissioned the victor of Venice to fashion their and their spouses' likeness for eternity. Tastefully, the Baron proceeded in private. The chocolate master, however, as is his habit, acted in the limelight of the world. When the Ludwig-Museum was opened in Cologne, he confided to *Der Spiegel*: "I think Breker is an interesting artist, a great portraitist... Certainly there is a penchant for conservatism around the world. I have followed Breker's work for quite a while. It was only a year and a half ago, however, that my wife and I decided to commission a portrait." The admirer of Cicciolina also offered an art-theoretical *aperçu*: "Postmodern — what does that mean other than being traditional?"[22] A week after the 1993 Biennale opening, an exhibition with the title *Ludwigs-Lust — Die Sammlung Irene und Peter Ludwig* is to be inaugurated in Nuremberg at the Germanic National Museum. To get the visitors in the right mood, the collectors will be introduced to them through portraits by Andy Warhol, Bernhard Heisig, Jean-Olivier Hucleux, and Arno Breker.[23]

As always, so too in 1993, Venice is worth a visit. The art world's logistical strategists booked hotels for the big days of the Biennale opening in June as early as

[22] Jürgen Hohmeyer, "Breker wird zur Seite gedrückt," *Der Spiegel*, September 1, 1986, Hamburg.

[23] Presse-Information (3). Germanisches Nationalmuseum, Nürnberg, July 1992. Only at the opening did it become clear that the Ludwig busts, in fact, were not included in the exhibition. Michael Eisenhauer, the curator, explained in the catalogue: "The debate which could have been triggered by their presentation would have perhaps diverted attention from the rest." A Breker statue of *Alexander the Great*, acquired by Ludwig for his private garden, was also not included.

137

Christmas. Travel agencies with an intimate knowledge of the industry's needs have prepared informational pamphlets and are offering personalized service. The Danieli, a hangout of art stars, is making this pitch: "Over the past five years almost all rooms have been renovated in the CIGA Empire style. The spacious rooms have muted color schemes and luxurious marble bathrooms."[24] Old hands in the hotel industry remember CIGA Empire as the favored style of Count Volpi's hotel chain. For people with more exquisite taste there is the Cipriani on the Giudecca: "It is noteworthy for its exceptional comfort, amenities, personalized service, secure surroundings and refined taste."[25] The secure surroundings of the Cipriani are not emphasized without reason. For decades the bohemians of the art world stayed around the corner at the Casa Frolo. The establishment also knows how to fend off overtures from the working-class residents of the Giudecca. In fact, the Cipriani, with its refined taste and tight security, has proved itself an ideal *pied-à–terre* for the world economic summit. If need be, the American Sixth Fleet interposes itself between the Giardini Pubblici and the hotel with its concern for an atmosphere of total relaxation and privacy for intimate business transactions. During the time of the Biennale opening, a double superior room is available for 690,000 lire, (approximately $435). An additional value-added tax of 19 per cent is charged. However, given the deterioration of Italian currency, the tax will be of little sig-

[24] *Biennale Venice 1993*, promotional flier, Humbert Travel Agency, Inc., New York, 1993.
[25] Ibid.

nificance for foreign clients. The Cipriani name is a guarantee of good company in other ways as well. Since preparations for the 1993 Biennale have entered their final stretch, Harry Cipriani is commemorating Ernest Hemingway, his father's loyal drinking buddy. His own bottom-line double-page advertisements: "I think that having the American Express® Card, the world becomes smaller"[26] (years ago American Express had already contributed to the *Mystic Lam* in Ghent). Deutsches Reisebüro is encouraging its clients to think of intimate settings, too: "How about an exquisite dinner for two at Antico Martini's or at Harry's famous bar?"[27]

A desire for a global love-in was at the birth of the Biennale. It still moves masses of visitors to Venice a hundred years later. Riccardo Selvatico, an author of comedies and mayor from 1890 to 1895, together with local artist-friends, invented the Biennale as an international sales exhibition.[28] In his appeal to German artists to participate, he declared: "The city council of Venice decided to establish this art exhibition, because it is convinced that art indeed is one of the most valuable elements of civilization and that it offers an unprejudiced decision of the spirit and the brotherly union of all peoples."[29] Thanks to excellent publicity, 224,000 visitors came to the first Biennale. There were also sales.[30] Selvatico, the good soul, was replaced by a

[26] American Express, double-page advertisement, *Art News* (April 1993), pp. 5–6; also *New York Times Magazine* (March 7, 1993), pp. 8–9.
[27] *DR Tour: Städtereisen* (Deutsches Reisebüro GmbH: Frankfurt, 1992).
[28] Isneghi, "Die Biennale."
[29] Cited in Lagler, *Biennale Venedig*, p. 20.
[30] Isneghi, "Die Biennale."

clerical-conservative coalition, of which the first general secretary of the Biennale, Antonio Fradeletto, was an active member. He was a traditionalist art historian of the University Ca'Pesaro in Venice. Under his aegis the exhibition developed as an event to benefit the local restaurant and hotel industry and an asset in the development plans of the Venetian establishment. As is the case with World Fairs and the Olympic Games, local investment policy and the insatiable desire for national representation happily joined forces also in Venice in an ideologically saturated arena.

The Biennale troops traditionally pass their busy days at the Paradiso or the Florian on the Piazza San Marco and continue into the wee hours at Harry's. In case of doubt, the bills are processed as tax-deductible business expenses. However, the excursion to Venice not only satisfies everybody's understandable needs for relaxation and disinterested pleasure; the traders, producers, buyers and cultural officials, the press and the hangers-on, they all flock to the Venetian get-together to spy ("information is power"), to develop and push opinions, and of course, to nurture old and to establish new friendships and business connections. What is at stake isn't chicken shit. The Venetian gift for comedy, marrying big money and sublime art, challenges today's jet-set actors to rival the Serenissima's model with contemporary versions of intimacy, chutzpah, and nonchalance. *Honi soit qui mal y pense.* A few days after the frolicking of the carnival in Venice, the show moves on to the hard sell of the Basel Art Fair, and, depending on one's taste, it could end in Nuremberg with *LudwigsLust.*

One would underestimate the Biennale (held on a site where Napoleon razed a monastery 200 years ago to make room for a park) if one were to think that it is only concerned with development aid for Venice and dividing the secular shares of the art market. Philip Morris, at least, was not fooled, when the giant consumer goods corporation sponsored the American pavilion of Isamu Noguchi in 1986.[31] The Marlboro cowboys couldn't care less whether Noguchi's prices would go up. Living in the saddle all their lives, they understood one thing: "It takes art to make a company great."[32] One might be tempted to assume that the weather-beaten fellows with big hats were thinking of paintings of their horses, or of fiery sunsets behind the Rockies. No, they are used to more powerful stuff. They aim at the big show places for "high art" around the world. One can surmise what they are looking for from the jargon with which such behavior is analyzed in a book published by the *Frankfurter Allgemeine Zeitung* [FAZ, German newspaper; conservative]: "Sponsoring has three central communications goals: recognition, attitudes, and the promotion of good relations." What matters is that "the positive image of the sponsored is transferred to the sponsor (image transfer)". FAZ summary: "Sponsoring is an opportunity to cultivate relations with selected big clients, trading partners, opinion makers and opinion multipliers, in an attractive

[31] Also the 1993 exhibition of Louise Bourgeois was sponsored by Philip Morris.

[32] Philip Morris slogan on double-page advertisements in the American press, announcing art events sponsored by the company during the 1970s and 1980s. In Italy, during the Biennale year of 1993, Philip Morris presented itself with the slogan *La cultura dei tempi moderni.*

setting."[33] The oil men from Mobil are more direct. They call it "Art for the sake of business." For those who are a bit dense they elaborate: "What's in it for us — or for *your* company? *Improving — and securing the business climate.*"[34] In plain English, this means low taxes, favorable regulations in the areas of commerce, public health, and the environment, governmental export assistance, irrespective of the nature of the products and the politics of the country of destination, and a defense against criticism of the sponsor's conduct. For example, behind the smokescreen of art, it is easier for the *Wehrwirtschaftsführer* [Third Reich term for leaders of the defense industry] of Daimler-Benz to rid themselves elegantly of pesky reporters inquiring about the company's chumminess with Saddam Hussein and the Iranian Revolutionary Guards. Alain-Dominique Perrin, the boss of the Cartier bauble shop in Paris, once described this mechanism in exquisite, amorous terms: "Sponsoring art is not only a fantastic communications tool. It is much more than that. It is a tool for the seduction of public opinion."[35] The best part is that the seduced are allowed to pay for the aphrodisiac expenses incurred in their seduction. They are tax-deductible. The cowboys with their cancer sticks simply followed their innate country smarts when they decided to take Noguchi along for a ride. "Culture is in fashion.

[33] Manfred Bruhn, *Sponsoring: Unternehmen als Mäzene und Sponsoren* (Frankfurt/Main, 1987), p. 87.

[34] "Art for the sake of business," Mobil Corporation advertisement, *New York Times* (October 10, 1985).

[35] Alain-Dominique Perrin, "Le Mécénat français: La fin d'un préjugé," interview with Sandra d'Aboville, *Galeries Magazine*, no. 15 (October–November, 1986), p. 74.

142

All the better. As long as it lasts, we should use it," applauds the gentleman from the Place Vendôme[36] (apparently he is aware of the impermanence of the high entertainment value culture enjoys at the moment).

According to Thomas Wegner, who staged a fair of electronic consumer products (MEDIALE) laced with art in the 1993 cyberspace of Hamburg, "art events of the scale of documenta or the Biennale are modern myths."[37] Public relations experts and their marketing colleagues have gleefully discovered that, of late, the prestige and the symbolic power of these and comparable mythical art institutions are at their disposal. Art still exudes the odor of the Good, the True, and the Beautiful, an unbeatable image-transfer offering. Because it is not suspected of serving worldly interests, the Good, the True, and the Beautiful (GTB) represent an enormous symbolic capital, even though it cannot be put into figures. In his Biennale call, the mayor/ comedy writer Riccardo Selvatico had declared that "art is one of the most valuable elements of civilization" and that it offers "an unprejudiced decision of the spirit."[38] Managers do not need to worry about what this may mean, as long as their target groups believe in the immaculate conception and no mass lay-offs are in the offing. While Casanova, that great Venetian expert, has taught them that not just anything is

[36] Ibid., p. 75.

[37] Thomas Wegner, "Bei der MEDIALE gehen Markenartikel und Kultur eine Ehe in getrennten Schlafzimmern ein" (At MEDIALE, brand-name consumer goods are joined in a marriage with separate bedrooms), interview, *Prinz-Stadt-Monitor* (February 1993), Bochum, p. 15.

[38] Cited in Lagler, *Biennale Venedig*, p. 20.

suitable for the enterprise of seduction, they can rely on the art institutions to choose the appropriate means. We know from Philippe de Montebello, unquestionably a connoisseur of the milieu, how the internal control mechanism of sponsoring works: "It's an inherent, insidious, hidden form of censorship."[39]

GTB not only serves as a lubricant and constitutes exchange value in art markets. The Good, the True, and the Beautiful are empty terms, ready to be filled by any number of different contents. It is therefore not surprising that fierce arguments have always raged among producers and traders, as well as in the warehouses, over the dominance of this or that ingredient. And not only there. When it comes to the definition of the Good, the True, and the Beautiful, more is at stake than parochial politicians of the art world sometimes imagine. Determining language is ideological and political management — to be sampled also in what has filled the pavilions of the Biennale over the past 100 years.

On October 3, 1786, Goethe wrote in his diary about his visit to the Chiesa dei Gesuati at Zattere in Venice: "Gesuati, a true Jesuit church. Merry paintings of Tiepolo. On sections of the ceiling, one can see more of the lovely saints than their thighs, if my perspective does not fool me."[40]

[39] Cited in "A Word from our Sponsor," *Newsweek* (November 25, 1985), p. 98.

[40] Johann Wolfgang Goethe, *Tagebuch der Italienischen Reise 1786: Notizen und Briefe aus Italien mit Skizzen und Zeichnungen des Autors*, ed. Christoph Michel (Frankfurt/Main, 1976), p. 114.